PHOTOGRAPHING

AND ALL THE KIDS AND FRIENDS AND ANIMALS WHO WANDER THROUGH TOO

YOUR FAMILY

While Visions of Sugar Plums danced in their heads...

JOAN

Happy Holidays

WARM WISHES For the Holidays

Christmas on the Farm

'97

Happy Holidays

PHOTOGRAPHING
AND ALL THE KIDS AND FRIENDS AND ANIMALS WHO WANDER THROUGH TOO
YOUR FAMILY

BY JOEL SARTORE WITH JOHN HEALEY

NATIONAL GEOGRAPHIC
WASHINGTON, D.C.

TABLE OF CONTENTS

LET'S GET UP CLOSE AND PERSONAL

by Joel Sartore

So you say you want to make great pictures. You want them to look like they came right from the pages of *National Geographic Magazine*. No problem. You've come to the right place.

Believe it or not, you already have the two key ingredients for getting really great pictures: Time and access.

Being in the right place at the right time and having close-up, intimate access to your subject are what it's all about.

So what's the one thing we all have time for and access to? Our families, of course. With every moment of joy or sadness, every up and down or bump in the road, the possibilities are endless.

If you're living with someone, you have better access to that person than to anyone else on earth. That's huge when it comes to getting great shots. But should you shoot everything?

No way.

In fact, you shouldn't shoot most things. Bad light, bad composition, and sensitive subject matter are all red flags. There's a time and a place for everything.

And just because they're pictures of your family doesn't mean they should be boring. In fact, the opposite should be true. Because you have unlimited time and access, your family photos should be the best photos you've ever taken. Just be discriminating. Remember, not everything your loved one does merits photographic preservation.

That cliché about torturing people with endless vacation pictures exists for good reason. Most people don't care about your children or your pets the way you do. That's why it's so important to make every picture count.

Put some thought into it, and the payoff will be manifold. Your friends will stay awake during slide shows, and you'll have truly great images that will last a lifetime.

But we're not getting any younger, dear, and neither are your family members. So where should you start and what should you do? The answer is in your hands.

The fact that you're reading this now is your key to making the photos you've always hoped for.

So, congratulations. Now let's get started.

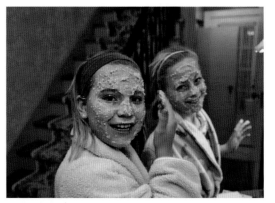

I usually keep several cameras ready around the house so I can capture spontaneous moments easily.

FIRST THINGS FIRST: KNOW THY CAMERA

Do you know how to use your camera? Don't be scared. You don't have to know every bell and whistle. I shoot for *National Geographic*, and I still don't know many of my camera's special "menu" settings. However, I do understand how to get my camera to do what I want it to when I want it to, and that's critical.

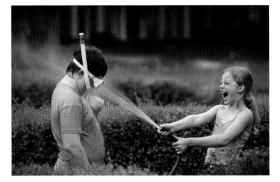

Siblings provide many opportunities to document family life—some good, some bad.

eras have many limitations, and even the most expensive ones cannot see the range of low light that our eyes can. Besides, some things—like the silhouette of a giggling child running after fireflies—are better remembered than photographed.

Getting comfortable with that little box is so important and really not very complicated. In fact, there are just two things that have made all cameras work since they were invented: aperture and shutter speed.

Aperture is simply the hole in the lens that allows light to pass through to your camera's light sensor, (or film). Shutter speed is the amount of time you allow for that to happen. That's it. Isn't that a relief?

Aperture and shutter speed work as a team. You adjust both of them in various ways to get the results you want. Though all modern cameras have automatic settings, it's a good idea to know how to manually adjust your camera's aperture and shutter speed. From pets playing in the snow to the kids on Halloween night, you can make great pictures every time, but only if you know how your camera works.

Also, learn how to shoot without flash, and to record a scene in low light. Nothing wrecks a subtly lit scene faster than harsh, direct flash. Learn the limits of your camera as well. Most consumer cam-

LET THERE BE LIGHT (AND A CLEAN BACKGROUND, OF COURSE)

Good light is one of the most crucial components in image making. Harsh, nasty, midday sun makes people squint and dogs lay down in the shade.

Concentrate on shooting outdoors when the sun is close to the horizon—sunrise and sunset. Even better, shoot when the sun is below the horizon. You'll get a beautiful, colorful glow over everything in your photographs. People will think you're a genius.

But wait, there's more. Good light can also be found on overcast days, when a cloudy sky mellows the light like a giant softbox. I love stormy weather as well, when the light is dramatic, ominous, and interesting.

Open shade is another wonderful light source. This can be against the shady side of a building or next to a window when you're indoors. Use any trick you can to soften the light. And don't forget that tungsten bulbs (standard, indoor lightbulbs) throw off great light as well. Their glow can warm nearly any interior scene.

Backgrounds are even more important. Believe it or not, I often construct my pictures from the rear

forward. If I can't make the background look good, I move on.

You can really tell if photographers know what they're doing by looking at their backgrounds. Are there streetlights and tree limbs sticking out of loved ones? That's the mark of a rookie. How about a dog in shade with the sky behind it all lit up? Again, unless the photographer was intentionally going for a silhouette, that's amateur hour.

I can't stress this enough: *bad backgrounds wreck pictures*. The only way to beat this problem is to actually stop and look around and think about what you're seeing. There is no magic formula; just effort and thought are required.

Whenever I'm starting to shoot something, I always think, "360 degrees, bird's-eye view, worm's-eye view." I learned it in journalism school, and it's a lifesaver. It means I look around in a complete circle and find the best direction to shoot in. I also think about shooting from overhead, birdlike, and from ground level, wormlike. Usually, I can decide the best vantage point that way.

For example, most houses have quite a bit of clutter, so I often get above my subjects and shoot straight down, using the floor as my background. That simple move nearly always cleans things up (provided there's some empty floor space, of course) and allows me to get to the essence of whatever I'm trying to illustrate.

This works with babies especially well. They're one of the toughest subjects to shoot because they never, ever, hold still unless they're sleeping. So I

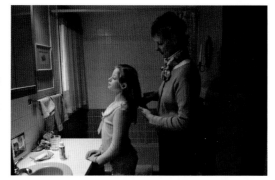

Kathy helps Ellen with her hair one day in the bathroom. The light is from a single tungsten bulb on the wall.

put them on a bedspread or a quilt and shoot straight down. Everything is in focus and the angle is different enough to pleasantly surprise the new mom and everyone else who sees it.

If nothing looks good to me after trying all angles and light sources, I take no for an answer and switch locations. It doesn't have to be a big move, mind you. Maybe it's from the front yard to the backyard, or from the kitchen to the living room. I'm just looking for the light, thinking of the space I have to work with as a stage, then hoping the players will do something interesting.

Speaking of interesting, that's the final component of any good picture. Yet this is often the hardest part because it takes time and effort and you have to be ready when the good pictures happen. I keep my camera nearby at all times, but I don't shoot very much at all when I'm home. I just want the good stuff, and it surprises me what that ends up being.

One day I came down the stairs to find my daughter, Ellen, and her friend Maris covered in green goo. They had made mud masks out of oatmeal, yogurt, and green food coloring. Another time my son Cole tried on a diving mask and allowed Ellen to pummel him in the face with a hose turned on full blast.

Being selective about what you shoot is tough, but it's the key to making really interesting frames. Ask yourself, "Should I take a picture of that?" and most of the time, the answer will be a resound-

ing *no* because most of the time the light is too harsh, or the kids or the cat or the spouse are not really doing much. Think about why you're taking these images. Are they to preserve some special moment? Are you going to show them to people? Is it worth their time and yours? Have you captured something funny, something joyous, something peaceful, something sad? It can all be good, but you have to give it some thought and time.

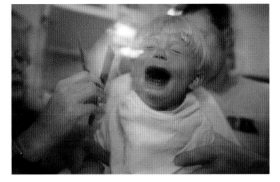

Emotion—any kind of emotion—is an important part of a photograph.

DON'T BE A STIFF

Shoot candidly. Nothing bores me more than seeing photos of people standing stiff and smiling just because the camera is on them. They all look like bowling pins. My mother's camerawork is gawd-awful, for example. She has this little point-and-shoot thing and drags everyone out in front of it, then lines 'em up and shoots. It's predictable and irritating.

The other day, my three-year-old, Spencer, was playing peacefully with blocks at my mother's house. Instead of quietly shooting that, she brought him into the kitchen and shot him from the waist up with a direct flash. He braced for the worst with a grimace on his face, knowing the flash would blind him. She got mad because his eyes were closed and took another shot—with flash. He closed his eyes again, and things went from bad to worse until he cried and kicked over his blocks—the ones she should have shot him playing with in the first place.

Then there's my wife's family. They have scrapbook after scrapbook, hundreds of photos of the same smiling people standing in their kitchen, all lined up like a picket fence. The kitchen stays the same but the hair gets grayer throughout the pages. That's the only change. You could make a flip book out of this stuff and watch them age, but instead I just think about all those missed opportunities. The people in these photos all lead really interesting lives.

Wouldn't it have been better to show Cousin Jim on his tractor planting wheat, or Grandma Lillian at her sewing machine? What about brother Frank working on his first truck, or sister Marty driving a cab? Anything other than standing in that same kitchen wearing a smile. Please! I'm begging you.

If you have to shoot in a kitchen, why not show the meal being prepared or folks laughing around the table during the meal. And how about your gorged relatives laying around the house in post-meal bliss? That's the good stuff.

But don't forget to shoot a few of the bad times, too. Got a flat tire along the interstate and the designated tire changer is throwing a fit? Shoot it! Baby crying? Shoot it! Kid home sick with the flu? Shoot that, too. But not too much. Just a little will do. Tell them you're recording *all* the times of your lives. And don't forget to turn the camera on yourself, especially with no makeup and your hair a mess. Someday soon you'll get a huge kick out of looking at photographs that are *real*.

Let's dwell for a minute on one particularly sore subject between my wife and me: crying baby pictures. I know that most people react to a wailing baby like they would to a fire alarm going off: They do anything they can, as fast as they can, to make it stop.

But wait a minute. Get a picture or two, very quickly, before putting that fire out. You'll be glad you did when that child is grown.

Sunsets and sunrises are two optimal times of day to take pictures.

GO BEYOND THE OBVIOUS

Something the best photographers always strive for is to shoot the unexpected. To do this, we go behind the scenes. We shoot the area where the parade stages rather than the parade itself. We're looking for the little surprises.

Those unexpected moments come when folks are not necessarily bracing for a camera. I often photograph a group getting ready to have their picture taken, for example, because that's far more interesting than the more formal portraits to come. Think of a bride getting ready for her big day—the anxiety, the laughter, maybe even some nervous tears, and the comfort of her parents and friends.

Don't be afraid to use props either. These are the things we take comfort in, the things that mark our lives. Blankies, special gifts, pets, shoes, first cars—you name it. All can be used to mark time, something still photographs do exceptionally well.

Finally, if there's one thing I've learned from years of experience, it's that sleeping people make for some really nice and improbable pictures. Best of all, they're relatively easy to photograph (at least

until they wake up and start yelling at you).

So much time is spent asleep, and yet so few photos exist. Why is that? You have access to your sleeping family members all the time. Take advantage of that and learn about exposure and composition at the same time. It's a beautiful thing.

Slumbering kids, spouses, friends, pets—all can make excellent pictures. They don't complain and they lay very still, both great attributes in photo subjects. Best of all, with sleep shots you get to go beyond the obvious. These are candid, real moments, sublime and eternal. In the hour after the late news or in the quiet before dawn, you have the chance to literally stop time, a single moment captured in which your seven-year-old will forever be that age, innocent and unspoiled, dreaming of nothing more than her favorite flavor of ice cream.

Tripods come in extremely handy here, as does a quiet camera or at least a pillow over the thing to muffle the sound. And don't forget your cable release so as not to jiggle the camera during the exposure. Also, if your spouse is easily offended, make sure you've lined up a friend's couch or a nice motel for a day or two while he or she cools off.

NOT EVERYTHING IS MEANT TO BE A PHOTO SHOOT

There are many, many times when taking pictures is not appropriate. Ever see a fumbling, oblivious photographer draw attention away from a wedding ceremony? Not cool. Or how about the obnoxious

click of a shutter during a school exam?

Know your limits at solemn ceremonies. Ask permission to shoot sensitive subjects, even among family members. Think about why you're recording the event. Do you actually want to re-member something as

Rainy days are excellent for making different pho-tographs. Just be sure you keep your cameras dry.

heart-wrenching as a funeral? I know I don't. But there are some difficult times, such as a son's loss in a baseball tournament, that might be perfectly appropriate to shoot. After all, life has highs and lows, and it's important to reflect that.

So be aware of your surroundings, of each situation, and use common sense.

And there are some moments that are meant to simply be enjoyed and not recorded. I remember once I was assigned to photograph tourists watching California gray whales in Mexico. We were sitting in these little boats when some friendly whales actually came right up to us to be petted. It was an amazing life experience. Yet some of the folks in the boats never, ever, put down their cameras and touched the whales. What a tragedy. They should have re-corded things for a minute or two, then stuck their arms in those whale mouths, right? Right.

But I'm guilty, too. For the birth of my first child, Cole, I decided I was going to shoot the delivery. And since my motto is "Go big or go home," I did it up right. I had lights, a tripod, two cameras. I even had a remote camera that was fired with a radio trigger, so I could shoot with a foot switch as I handed the baby to my wife. It all made great pictures, and it was simply pathetic. By working the situation so in-tensely, I literally missed the entire experience. I'm not proud of that.

During the birth of my second child, my daughter Ellen, I cried like a baby myself. On purpose, I had left my camera at home. It was the best shoot I never did.

Please remember, they're just pictures. Put it in perspective. A hundred years from now, nobody will know you existed. Ever see people who are vid-eotaping every moment of every game their kids play? Or snapping stills endlessly at school plays or piano recitals? Who in the world will be willing to look at all this stuff?

Is that harsh? Maybe, but somebody has to tell the truth, and it may as well be me, an objective observer who has had to sit through *way* too many bad slide shows. It's truly mind-numbing.

So, all things in moderation. Shoot a few then put the camera away or it becomes work, not fun. Your family and friends will love you for it.

THE BOTTOM LINE

Finally, and most important: *Have fun!* Take what you've read here and make up your own mind. Make photos that break all the rules. Go for it, with gusto. Push yourself. Be passionate. The results will be fabulous.

Above all, take the kind of photos you want to take, not the kind you think other people want to see. Does that contradict a few of the things I've said? You bet. But then again, the first rule is: There are no rules.

JOEL: The amazing thing about still photography is how it freezes time. This may look like it's from an extended shoot, but actually it only lasted a second, when Spencer looked up from a pine cone he'd found. Most of the time he was running around, exploring the yard. I felt lucky to get even this single frame.

Chapter One

TAKE BABY STEPS
WITH YOUR CAMERA

JOEL: I often try to photograph my kids when they're sitting still and preoccupied with something else. I get more time with them this way, and it's more pleasant for everyone. In this case, Cole was simply sitting and watching television.

TAKE BABY STEPS WITH YOUR CAMERA

There's probably no better time than your first year of parenting to learn photography. You have the cutest subject on earth, and you'll be spending lots of time with him or her. What better way to remember that first year than by keeping a photo diary of it—and along the way becoming a better photographer as well? Learning photography can be a lot like those first few weeks of parenthood: You're not quite sure what you're doing, and you seem to be juggling many new skills at once (with hopefully more sleep than new parents are getting). But like parenting, it just takes time—and practice—to get it right. Soon enough, you'll find taking great photographs as easy as changing diapers (and a lot more pleasant). To help you grow as a photographer, I'll break down the photographic steps you should be taking that first year. I'll introduce each concept individually, hoping you'll combine them as you need them in your photography. By the way, expect to make mistakes, some of which you will love. In photography, the mistakes can sometimes be brilliant. Let's hope the same holds true for parenting.

HOW TO USE YOUR CAMERA

Camera manuals usually rank somewhere between legal documents and tax manuals on the fun-to-read meter—and that's if they've been translated well from the language of their original printing. But reading yours gives you a fighting chance of figuring out what all those buttons do, and which ones you do and don't need to pay attention to. You may find out you can make panoramic pictures or that you have the option to make a short film. Even after many years with basically the same camera, there are still buttons I not only don't use but don't know what they do. Come to think of it, the same applies to my dishwasher and microwave.

Use your manual to learn to control the basics of your camera first. Here's a list of what to read over and familiarize yourself with:

- aperture: learn how to increase (a higher f/number) and decrease the aperture
- shutter speed: learn to raise and lower the shutter speed manually (not all cameras allow you to do this)
- focus: some cameras allow you to focus manually or to pick a specific focus point.
- ISO/ASA: either the speed of the film or the sensitivity of the digital sensor to light
- flash: learn to turn off and to increase or decrease the power of the flash (if your camera allows you to do so)

Either a digital point-and-shoot camera (above) or a D-SLR (opposite) is a good choice; it depends on your needs.

Wireless printer

Aperture priority

Trash for deleted files

White balance

Access camera menu

Self-timer, multiple exposure, and wireless remote

THREE KEY ELEMENTS

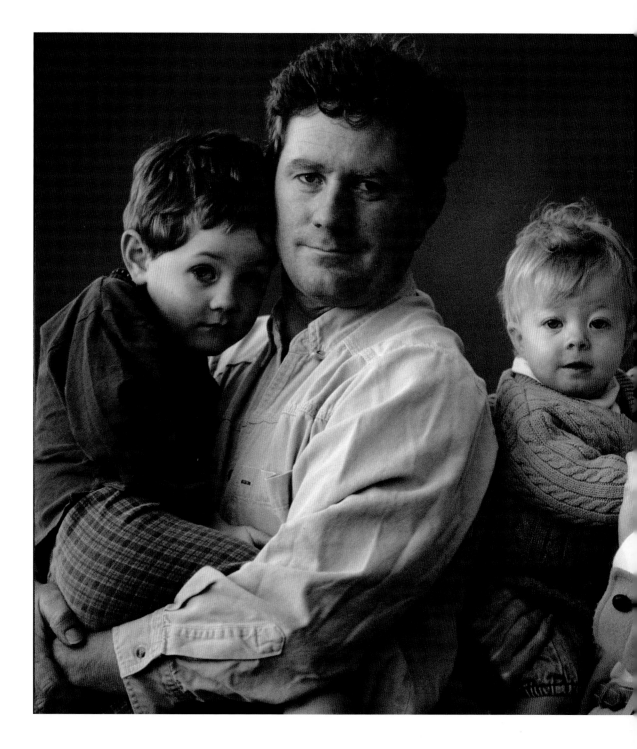

There are three elements that together create a good photograph: the subject, the composition, and the light. A decent photograph may have one of these; a good or great photograph may have two. A stunner will have all of them.

Presumably, you already have your subject (or are about to). Before you pick up the camera, give some thought to how you'd like to portray your family, how you'd like future generations to remember it. Do you spend a lot of time at home? Do you travel often? Is your home the center of the neighborhood? Are animals an integral part of family life? Are you sporty, literary, serene? Identify the kind of pictures you might want to take.

Now look at the pictures you already have. Do they represent what life is really like? Or do you have a lot of pictures of people grouped unnaturally close together wearing fake smiles on various holidays? That is not photography. They are photos, born from the need to take the picture as quickly as possible so everyone can relax.

The truth is that the pictures you truly will want to keep aren't staged. They're natural.

JOEL: This was shot on a tripod. I locked down the camera, focusing way out with a 400mm 2.8 lens (to mute the background). I could have used a self-timer, but that was a long way to run. It's easier to ask someone to press the button for you. My sister-in-law, Jeannie, fired the shutter.

Composition

Listen to a favorite song, read a poem, or look at a well-designed piece of furniture and you're enjoying the result of someone's—or several people's—artistic efforts. Good photographers are masters of composition, intuitively composing a photograph in an instant, the same way a poet may dash off a great verse.

Composition is innate for some; for others it's learned. But it's everywhere: the building you are in right now, the books you read, the pattern on your clothes. Even human attraction is determined by a person's physical composition.

Most people who don't use their cameras all that often, tend to center the subject to avoid cutting off hands, heads, or feet. This simple composition allows a bit of scene around the subject as well, but generally the subject dominates the frame.

Artful composition means one thing: being keenly aware of the surroundings of your subject and adjusting to make the best photograph possible. When including the "stuff" around your subject, ask yourself one question: How does your subject relate to its surroundings?

Think of your child's first Halloween outing. Who wouldn't want to snap pictures of that costumed creature? But as they walk home from trick-or-treating, consider where you want them in the frame. Typically, you might just shoot and not think about what surrounds them. Then your picture might also include the road, your front yard, a bit of porch, some sidewalk—and your

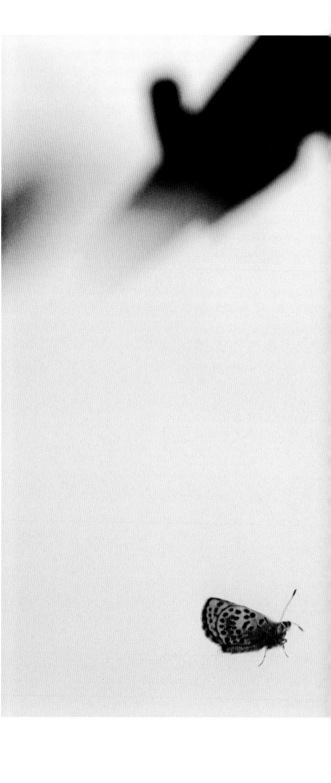

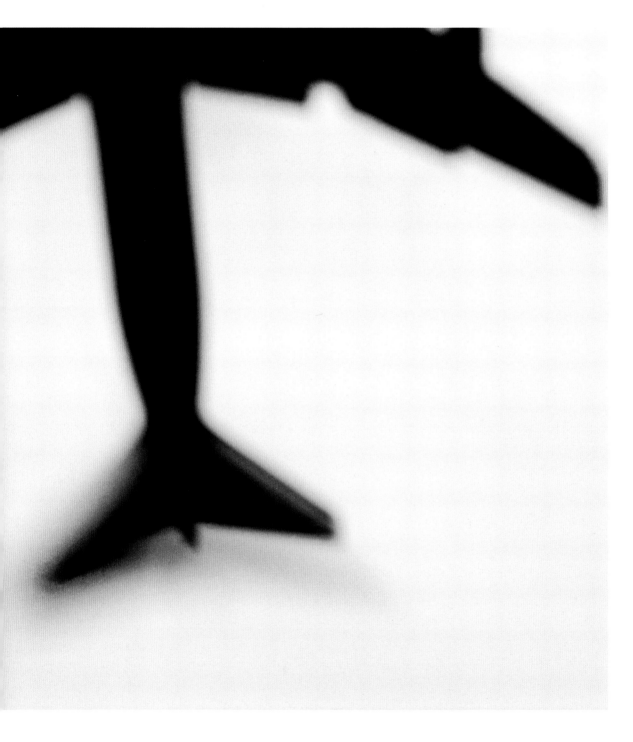

JOEL: For a story on the El Segundo blue butterfly, I wanted to show it lived near the Los Angeles International Airport.

JOEL: It took us three days to get the shot (on the previous page). We put the male butterfly in a clear Plexiglas window box and set it on a stand at the end of the runway at LAX. Butterflies are deaf so they didn't mind the noise. The trouble was trying to get the butterfly and the plane in the same frame. I used a wide-angle lens but the butterfly was walking around in there, and mostly he was in the corner when the plane was taking off overhead.

husband and child somewhere in there, too.

Taking just 30 seconds to think about how best to photograph your subjects will yield a very different picture. What happens if you shoot low, looking along the sidewalk? The line of a straight sidewalk will make an interesting "route" into the photograph, and shooting low also gets the evening sky in the picture. Together, these things clean up the frame and lead one's atten-

tion to what's important: the adorable child and the proud parent who just survived the rigors of trick-or-treating.

And beyond composition, you'll want to change how you approach your subjects. Forget "Hold still" and "Say cheese." Instead, try, "Let me see all that candy!" You never know what will happen, but you should be ready to capture whatever comes your way. Start with a

wide view to give yourself a chance.

If your beaming child grabs a handful of candy and throws it up in the air, *Snap*. Digs her hands into the pile of loot to show you the bounty? *Snap*. Once inside, have your child dump all the candy on the floor (well, he'll probably do that anyway). Rather than shooting from the usual standing position, tweak your angle a bit. Go right overhead: Stand directly over your treat-laden child and shoot straight down as he admires the loot surrounding him. Again, you can't be sure what you'll get, but at least you're working on some nice composition.

You could also get down very low and be with your child as they begin to dig through their bounty. Look at the foreground and background—if there's a mountain of candy in the foreground, that's a great feature to illustrate the first Halloween story. Now, check the background. Often, a slight adjustment on your part can clean up the background so the focus is solely on your child.

So what does good composition take? Nothing more than a little time and an awareness of what's around you. Simplifying what surrounds your subject is the big first step, but good photos come in many packages. For every picture with a clean, uncluttered background, there will be another that is equally nice despite its busy foreground and background.

It won't always be easy to find the right shot; each photo opportunity could present you with many different options for composition—some that work better than others. And a composition you love may be loved by you and you alone. But it's always worth a try. You may wind up with something truly magical.

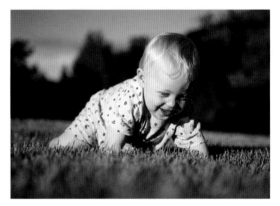

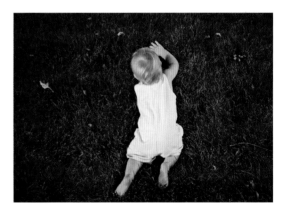

JOEL: *We were on vacation, and Spencer had just started crawling. I wanted to get as many pictures of the baby as possible, and he wouldn't stop moving. He was trying to get to his mother, who was in the house. When I lost the light, I just stood over him and shot straight down. This is a good example of the three ways I am thinking about a picture: worm's-eye view, bird's-eye view, 360 degrees. Where is the picture?*

Rule of Thirds

There are several guidelines for successful composition that are surefire ways to make your photographs better. The rule of thirds is the first rule photographers learn. Take any picture in your archive and imagine a tic-tac-toe grid drawn on top of it. Are there any interesting points in your picture that rest on the four places where the lines intersect? If there are, you have successfully used the rule of thirds. If most of your pictures have the subject centered in the picture, you need to experiment. By applying this rule, the pictures become intentionally asymmetrical and, often, more compelling. The next time you take a picture, imagine the tic-tac-toe grid on your camera lens as you compose the shot.

This may sound like an impossible task—trying to get a picture before the moment passes while, at the same time, imagining a grid over it so you can shoot your subjects in an interesting way. The key is not to become overly concerned with getting it all right. Instead, practice a few times in low-key, relaxed situations.

If it helps, follow the baby or the puppy around the house for an hour, shooting all the while. Train yourself not to simply put the attractive subject dead center in the frame.

When you've taken as many pictures as you and your subject can bear, compare the results. Are some more interesting than others? Were you successful at changing the way you see a photo? You might be surprised at how quickly you can alter your photos from standard family fare to something a bit more unusual.

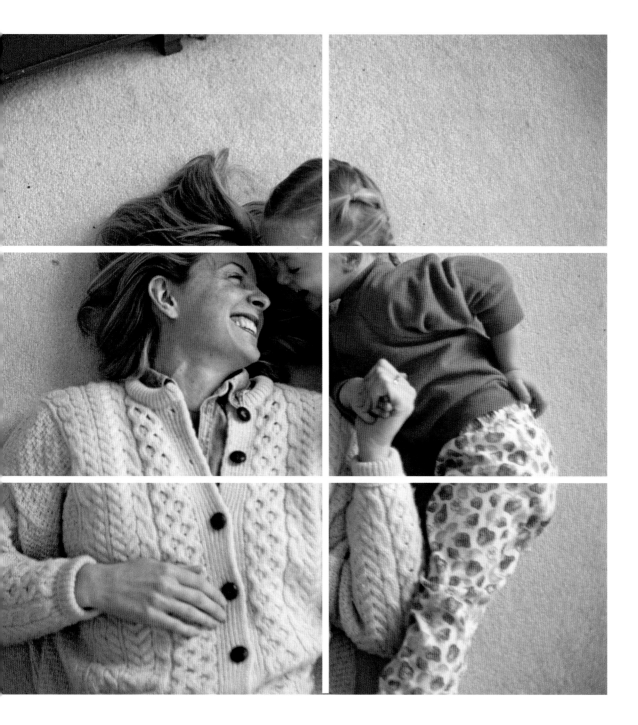

JOEL: *This is in Ellen's room. That room is extremely well-lit. They were playing on the floor. The walls are so cluttered in there I tend to shoot looking down in that room a lot. This angle works well provided the light is there. Floors in general make excellent backgrounds.*

Backgrounds & Foregrounds

Objects in front of and behind your subject are extremely important to your photograph. Get in the habit of looking at surroundings before you shoot and either reducing them (if they're a distraction) or incorporating them into the photograph's composition. You may try looking around the frame in a clockwise manner, noticing everything.

You can change the foreground and background quickly by raising or lowering your camera, turning it vertically, or just changing your position. There is no law that says standing upright is the best stance for taking pictures.

There are a few common mistakes to avoid with foregrounds and backgrounds. First, objects in or around the subject's head can be greatly distracting. Watch out for telephone poles, window frames, intersecting lines, and anything else that may look like it's sticking out of your subject's head. You'll also want to avoid anything of a greatly different color, contrast, or brightness that draws attention from your subject. Remember, if you're trying to get a great shot of your child, anything that competes with him needs to be minimized or removed.

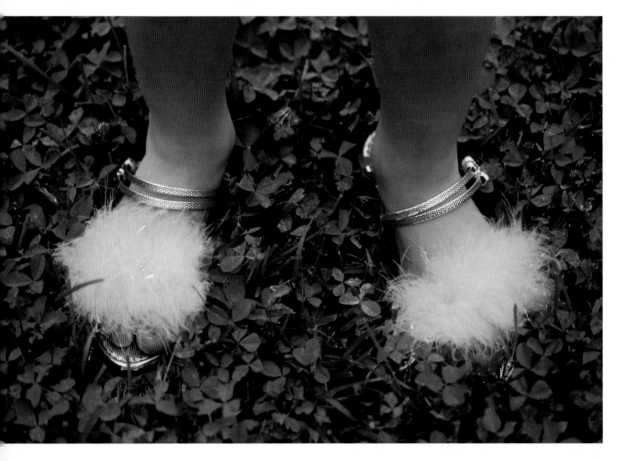

On the other hand, foregrounds and backgrounds can be very effective storytelling tools. Does it matter to your photograph that you and your subject are at a party? Do you want to incorporate the surrounding trees into your photograph to let people know how beautiful the site was? In some cases, you may want a stark, clean background. But in others, a little clutter is good.

The dog may seem like a distraction, but it can also make a great foreground element that captures the chaos of your growing family. Scattered toys and clothes may seem like a mess you want to hide, but they, too, can convey the havoc children and pets can wreak.

"Layering" a photograph is a technique that has the foreground, subject, and background each telling a little bit of the overall story. A simple example would be to include the chewed-up teddy bear in the foreground along with the family member who discovered it, and the humbled and guilty dog in the background. This type of composition may happen accidentally or intentionally. Either way, keep the idea in mind when you pull out your camera.

JOEL: I personally like the green as a background here but I shot the gray asphalt background first. My daughter, Ellen, picked the shoes. Kids do some amazing things and you really don't have to do a thing except be ready to get it.

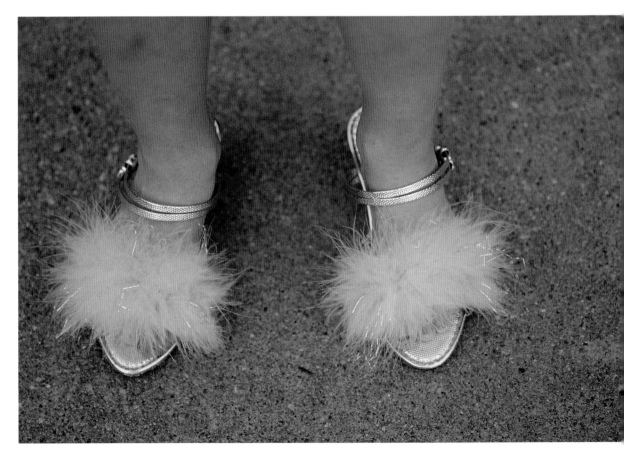

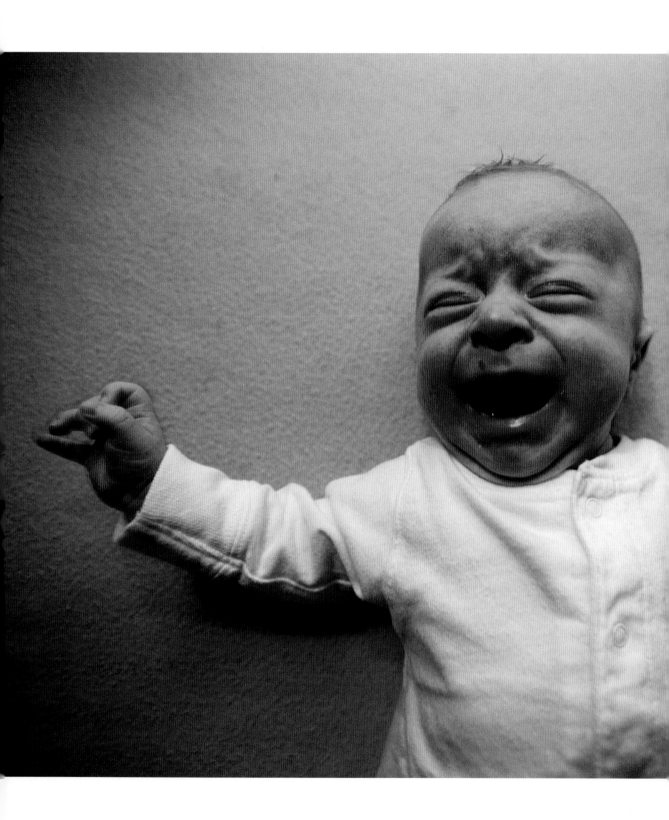

JOEL: *Kids are professionals at crying. This is my nephew, Sam. We were at my parents' house, and that's probably a green bedspread. I shot a few frames, and my brother Paul and his wife, Laura, were in the background, saying, "That's enough! That's enough!" But it's the pictures of the kids crying that remind us what it was like to be a parent with young children. They're entertaining, and they're emotional. And that's what a good photograph is: It is a picture with good light, a clean background, and some emotion.*

Closer & Farther Away

Like most people, you probably shoot most subjects from the same distance every time. Note where this is when next you pick up your camera, and then change it. Move in closer—much closer—until your child has completely filled the frame. Then step back. And then back more. Make your subject tiny in the frame. Just walking a few steps in either direction will radically change the feel of your photographs. And it's a cheaper solution than buying lots of extra lenses.

"Filling the frame" is a classic and effective way to take great photos, and it can be accomplished by either moving in close (filling the frame with the subject) or moving away (letting the environment fill the frame).

Say you're on a hike with your family and want to take a photo of your kids in the woods. Don't automatically take that shot from your usual, comfortable distance. Instead, back far enough away from them that the huge trees become the subject of the photo. The kids

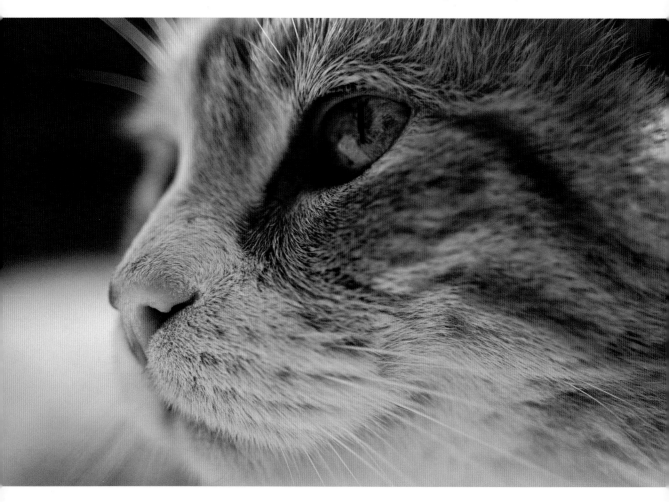

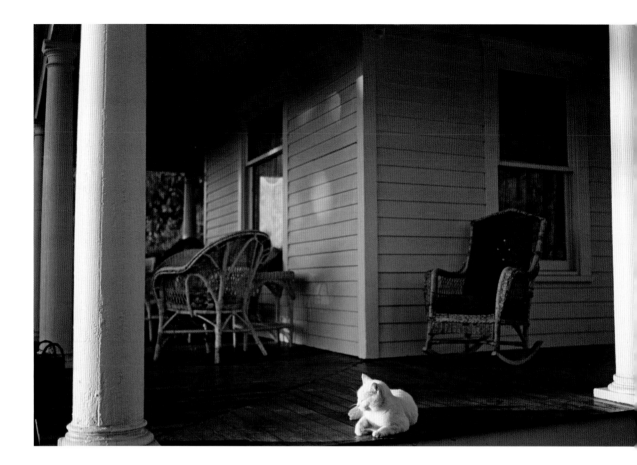

seem so small in the frame compared to natural elements surrounding them. This is what composition is all about—changing the idea of your photograph from something simple (children with trees behind them) to something more compelling and unusual.

Getting closer can create an intimate feeling in a photo. But keep in mind that some cameras and lenses may not be able to focus much closer than a few feet. A wide angle, for instance, can distort a person's face when placed too close. For fun, get as close as you can while still keeping the image in focus. Ignore the need to keep everything in the frame, and see what you come up with. You might even like a picture of a detail rather than the whole scene.

JOEL: *(left) I was over at a friend's house watching the Super Bowl, and this cat was sitting in front of a brick wall. The light wasn't great either so I used a 60mm macro lens to photograph him. The cat above was a stray who showed up on the farm one day at sunrise while I was getting ready to paint the porch. He matched the columns. I used a 20-35mm telephoto, wide-angle lens to capture as much of the porch as I could. I built this picture from the background forward.*

JOEL: *(following pages) This is an example where the background is the photograph, and the people are just props. I saw this cloud coming and loaded my family into the car to go to the highest point in Lincoln—on top of a dam—so I could make this picture.*

Macro Photography

Many point-and-shoot cameras have a "macro" function, which is the fancy photo term for "close-up." Some cameras have a lens that allows for close up photography, others have a "digital" macro capability, where the image will be cropped to simulate the use of a specialized macro lens. This mode is almost universally the "flower" setting of a camera's automatic modes.

First, find an area where there is ample natural light, preferably light that is soft and diffuse. This could be next to a window with a blind over it, or in a room where the light is bouncing off a wall. Try to avoid direct sunlight, both for the safety and comfort of your baby and also to avoid harsh shadows. It's also best to avoid artificial light, as it's usually not bright enough. You definitely want to avoid using flash here, as light coming directly from your camera will not be flattering and could distract your subject.

Next, pick a background to photograph baby against. Go for something simple, like laying baby down on a solid-color blanket. If the baby is sleeping, even better! Using the macro function requires a very still subject. Use your own aesthetic sense here, but remember you want all the attention on the details of your baby, not on a busy pattern in the background.

Set your camera to its macro or "flower" mode. Because this setting is an automatic mode, your camera will most likely set the ISO/ASA speed as well as aperture and shutter.

Begin to compose your photo. If your camera does not focus, you may be too close. Every camera has its minimum focusing distance, so you may have to move away a little bit. Another fact to keep in mind is that true macro lenses have very small planes of focus and, therefore, very little depth of field. This is why the macro function is great at reducing distracting backgrounds on its own.

Start off with a simple, straightforward photo of his or her hands—but try to fill the entire frame with just a hand or foot. Then try the opposite: What would happen if you leave a lot of white (or empty) space in the frame and put the toes or fingers right in the middle and bottom of the frame, with nothing else around them? If the background is distracting, doing something as simple as covering it with a white blanket will do the trick.

Don't limit yourself here to just the passive shots either. Your baby loves to be touched, and you can pick up his hand or foot to get a better angle. He'll enjoy the attention, and you might find it fascinating to slow down and study all these tiny features of your little one.

Go ahead and experiment with photographing their ears, eyes, little tufts of hair, and various expressions (even—or especially—the unhappy ones). What may seem like overkill while you're shooting will yield a batch of photos you'll look at with great affection.

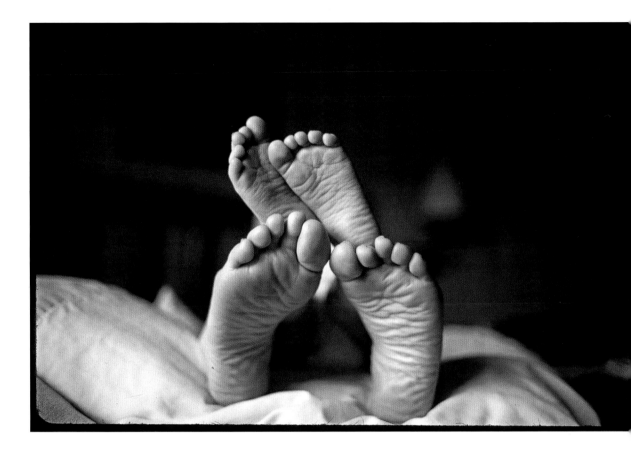

JOEL: *You can use darkness to create a clean background. We were in a hotel room in Chicago on a winter day. Spencer was lying on Kathy, and they were watching television. The curtain in the room was drawn halfway, so there was light cast on the end of the bed but not at the top. By getting down low and exposing for the light, I knocked out any distractions in the background to create a cleaner background in the photograph.*

Lower & Higher

Like distance from your subject, the angle you shoot from has also probably become a habit. Eye level? Boring, boring, boring. Get low, get high. Get overhead. Stand on a chair or a bed. Or lie down and snap the photo from the floor. You'll be amazed how just changing your angle can dramatically alter your photos.

Kids are often floor- or bed-bound when they are younger, so it'll be a good exercise to try to be at their level when taking pictures. For example, a sleeping baby almost always would be photographed from overhead. But what if you took a picture from the side, at bed level? What if you got down on the floor to place the blocks in the foreground while your child played?

This is exactly what a photographer does to make his or her pictures better: make a little (or a lot of) extra effort to capture a different look.

JOEL: I asked Kathy to hold Spencer up because I wanted to do a baby butt picture. He was wiggling, so he looks as if he was jumping out of the picture.

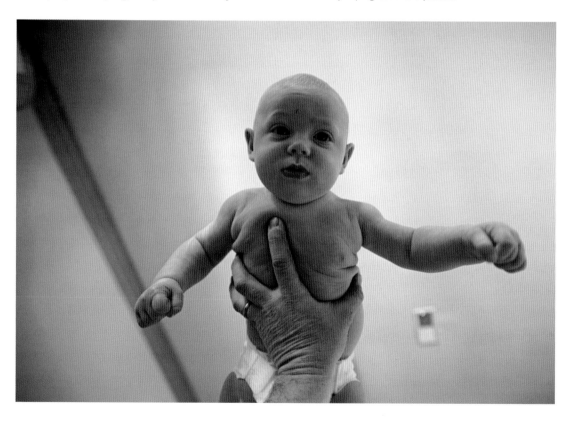

JOEL: Spencer was startled. I wanted to do this with him before he was too big, which he almost was in this photograph. It was too cold outside, so I decided to do the picture inside against the ceiling which is a nice, clean backdrop. I set the camera wide open at f/2.8 at 1/60 of a second and ISO 400 before I picked him up.

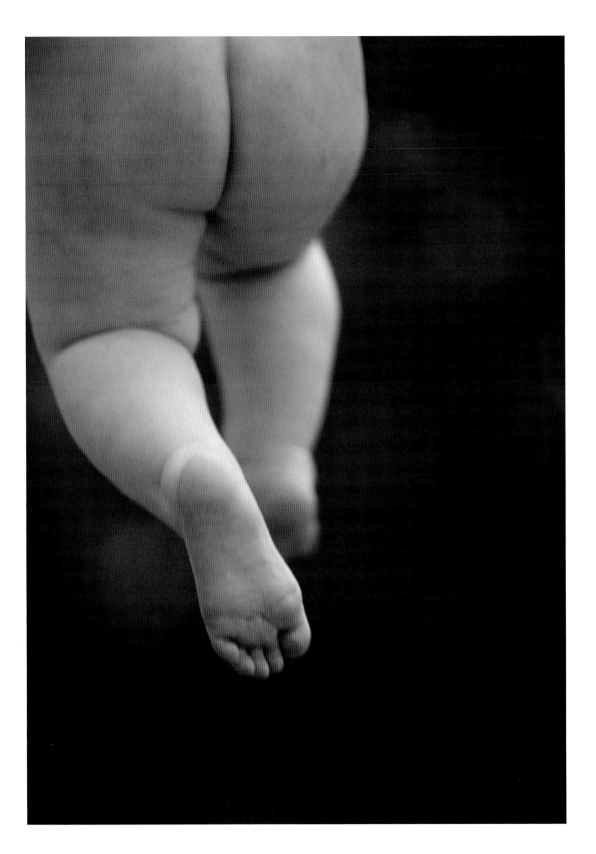

Shoot Vertically

Try using your camera vertically instead of horizontally from time to time. Notice how dramatically it changes what's included in the frame. Often, shooting vertically can clean up messy backgrounds and help better define your subject.

There are some times when it's better to use your camera vertically than horizontally: buildings, people (both for close-ups and for shooting only one or two people), and anything that is more vertical in nature than horizontal.

A vertical frame can also give great perspective when photographing wee ones—especially when they're on the floor looking up at a tall parent or napping in the shade of a towering tree. If you want a fun picture with lots of blue sky and a low horizon, a vertical shot is a good bet.

Also, look for the other composition concepts to suggest a vertical picture. Lines, color, balance, and weight are just a few of the things you might see in your viewfinder to suggest shooting vertically. Trees, balloons, windows, doorways— these are among the common objects that lend themselves to vertical photos.

Vertical photographs, especially when you're indoors, tend to limit other things and people in the frame, helping to simplify the subject. If your child is peering out the window and you take a photo from behind, a vertical perspective will emphasize the height of the window compared to the child's height and will also help reduce whatever clutter—furniture, for example—might show up in a horizontal frame. Generally, when you are indoors, there is often more "stuff" horizontally than vertically. Keeping this in mind can help you de-clutter your photos.

Using your camera vertically shouldn't be a rare occasion either. Yes, many cameras are built for predominantly horizontal use, but take a look through a favorite magazine (which, by the way, is in a vertical format) and see how many vertical photos are in there.

Again, give yourself the assignment of practicing vertical shots. Spend an hour or an afternoon shooting nothing but vertical photos. Do it when you're relaxed and have time to play, to look for situations that might work better in a vertical frame than a horizontal one.

Make this another exercise in changing the way you see subjects. Take photos indoors for a while, using windows, door frames, any vertical lines, to turn your usual photos on their sides.

Then move outdoors, where a child looking up a tree toward a squirrel or a bird can help you change your perspective to vertical. When you're done, compare the photos you've taken with some horizontal pics. This exercise could help you see the difference.

JOEL: Everything in this picture is vertical: the window, the building, even the boy. I had to shoot it vertically. I usually have to be hit over the head to shoot vertically because I don't think I do it very well. Moral: When the lines in a picture are leading you vertically, shoot it that way.

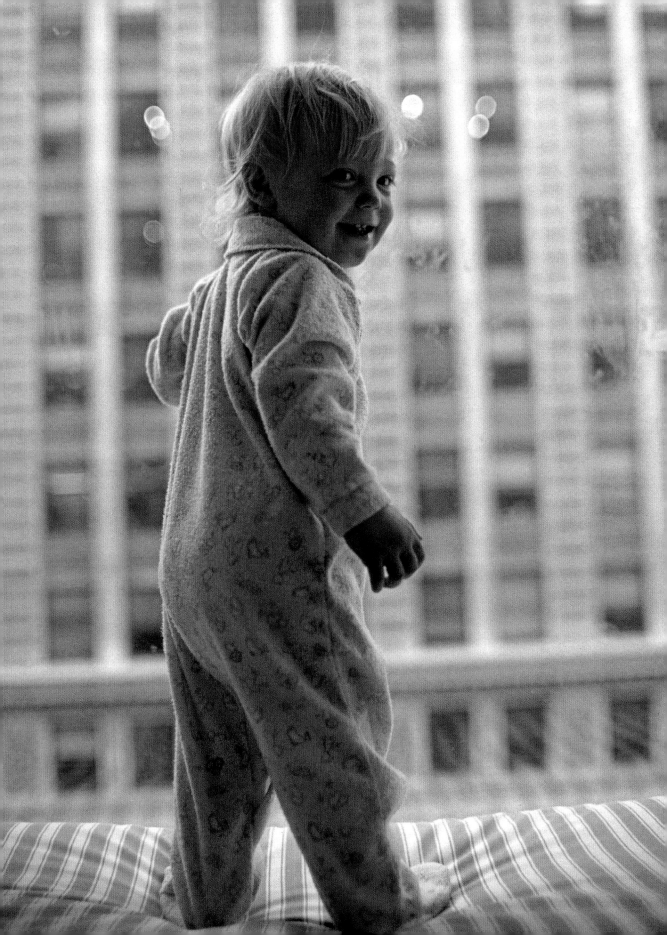

Experiment

There is no "right" composition, but there are certainly compositions that will elicit remarks like, "Wow! That photo is incredible!" This is the best part of photography. Have fun and play.

Don't limit yourself to just one or two photographs of each scene either. Professional photographers will take dozens of shots of every scene for many reasons. They might subtly change their composition, waiting for the right light, or they shoot continuously while waiting for the subject to land in the absolutely perfect position. In each group of photographs, several will be good, but many times one or two will be truly memorable.

Most of us have picture-taking habits; and these habits often get in the way of successful composition. We humans can identify good composition when we see it, but we can't necessarily replicate it.

Digging through vintage photographs at estate sales, flea markets, or antiques stores can yield many different composition ideas. You can find photographs from all over the world, the work of hundreds of amateur photographers— and you'll find compositions that are all over the map. You'll certainly see people and things centered, but every now and then you'll find a photograph more intriguing and complex in its composition. Maybe the photographer chose a different angle, got closer or farther away, or found some gorgeous light for the scene.

The first rule of composition? Don't center.

The second rule? Break the rules.

Try something new, shake off old habits, take risks. The payoff? Fresher photo albums with a whole lot more pizzazz.

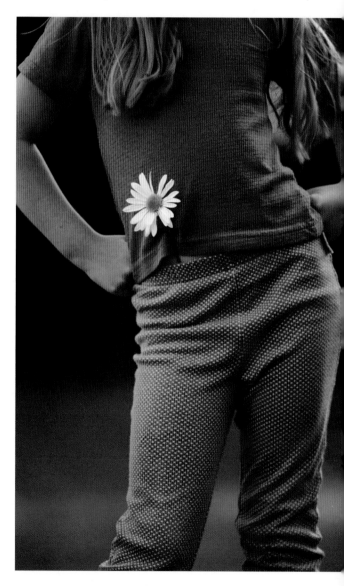

JOEL: *Ellen tucked the flower into her outfit at the end of the shoot, and I realized the detail shot counts, too. I think this is the best picture from the shoot.*

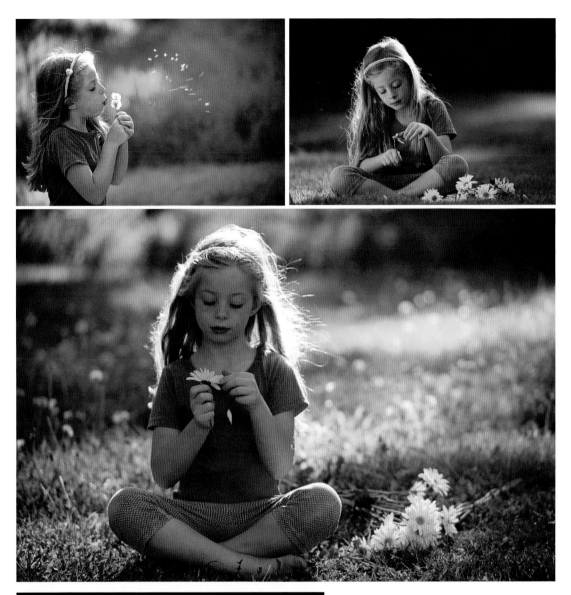

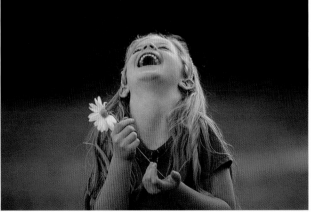

JOEL: *This is a good example of how many different ways you can make a picture. It's the same meadow and the same outfit. Ellen was pulling petals off the flowers on her own. She was blowing seeds and laughing. There's a bit of a gold reflector in some of the shots. An old newspaper trick is to think about the wide shot, the medium shot, and the tight shot when you are telling a story. It's more of a complete job that way.*

More Composition Ideas

Try as many composition techniques as possible with each photo you take—or at least as many as you have time for. As you master them individually, you can start to mix and match them in various situations.

Consider the background in your photo while also employing the rule of thirds. Use the rule of thirds and break the frame. Go in tight, tight, tight and still don't center that close-up. Then, break the rule of thirds. Put the subject back in the center of the frame. Change your angle, pull far, far back. Again, it's all experimentation, trying to find what works best for you and what appeals to you most aesthetically. There is no right or wrong, so be willing to try anything.

USE NATURAL FRAMES: Door frames, clouds, flowers —anything you see in your image can help to naturally frame your subject and create a strong visual center in your photo.

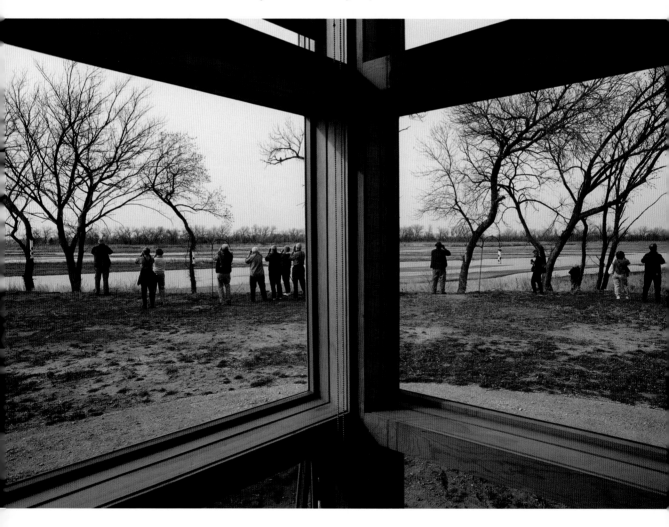

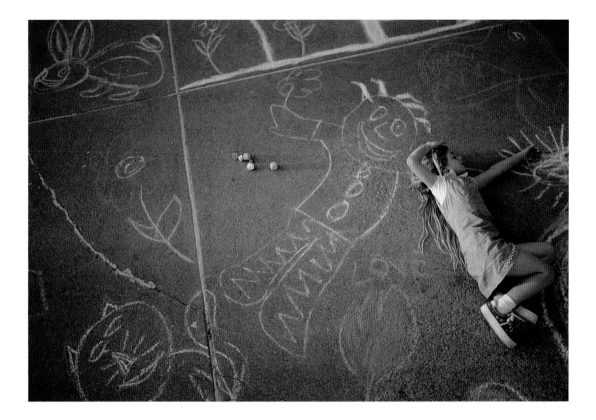

ABSTRACTION AND DETAILS: Don't limit yourself to subject-foreground-background composition. Ask yourself what is important in the photograph and then shoot in such a way that you capture it. If your child is atop something unusual or visually compelling, shoot from an angle that allows you to include all the important details.

BREAK THE FRAME: Common in movies, television, and photographs alike, "breaking the frame" means you artfully allow your subject to go out of the frame, so part of them is cut off. This can imply motion or a spatial relationship that extends beyond the edges of the photograph.

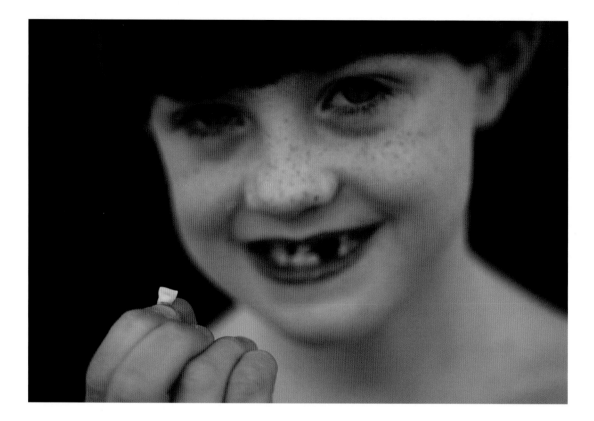

SELECTIVE FOCUS: Using a shallow depth of field, or getting very close to your subject, will blur out other elements in the photograph, leading the viewer's eye directly to what's important. You'd want to use this technique when photographing your child's hands or feet. Focus on just a few toes or fingers—or on that newly pulled tooth—while keeping an eye on what's in the background so it's not distracting

COLOR: Color can be one of the most eye-catching things you use to create great photographs. Experiment with contrasting colors, similar colors, or dominant colors in the frame. A blue sky is an easy way to use color—if you get low you can capture lots of it with your family in the photo. But also look for color-saturated walls—these can make fun backgrounds.

REPETITION: Notice repetition of elements in the frame and use it to create an interesting composition. A long fence, lots of brightly colored cookies, or kites in the air are but a few examples.

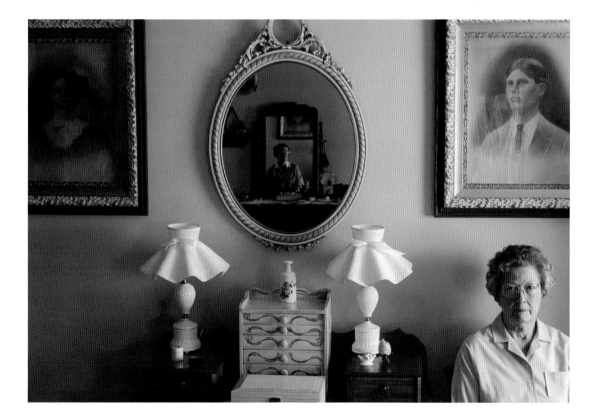

BALANCE AND WEIGHT: Notice how colors and dark and light areas affect the visual "weight" of things in your picture. Because everything has a visual weight, there will be a balance—or lack of it—in your photo. Here, the two portraits, the two lamps, and the oval mirror centered in the frame balance the photo so the unique position of my grandmother on the right draws your eye.

Light

Light is the very essence of a photograph. There are many ways to learn how different light can affect your photographs, but a good way is to watch a movie. Why? The light in a movie is precisely controlled to convey a particular emotion. Directors of photography in films are masters of light. Large movie budgets allow them to either wait for perfect light or create their own using pricey equipment. Even the briefest movie scene takes an astonishing amount of lighting work.

Light's many qualities offer myriad emotional choices for your photos. A blue cast can feel cold and desolate; while warm, red light soothes.

The direction of the light also affects how it feels. Long shadows in the evening make a different photo than the harsh, overhead light of noon. And no shadows at all—those few minutes just before or after sundown—can be otherworldly.

Shadows also can be revealing. Soft shadows signify a warm, romantic scene; while harsh, direct shadows show suspenseful moments.

Books of photographs can also offer a primer on lighting. Photographers tend to have light they favor, and you may begin to recognize that light in some of their best images.

Good light for pictures can be found anywhere, anytime. If you can learn to find it, your photographs will show the difference.

JOEL: *It was near sundown on a farm where we used to live. We were in the master bedroom, and I wanted to give a sense of the farm by framing the barn in the window. I posed other family members here, too.*

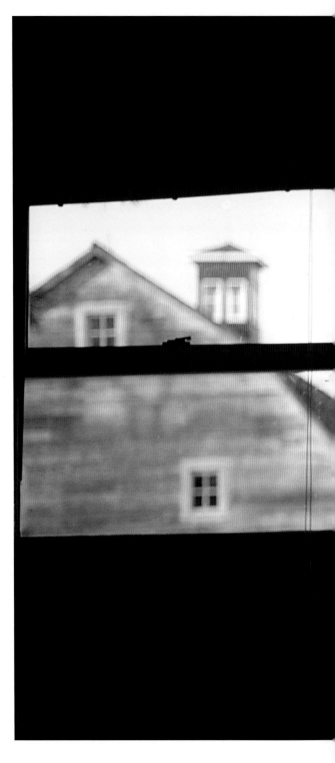

Your First Portraits

As your baby begins to sit up on her own, you can start to take portraits of her doing more than just lying down or wriggling on her tummy. Look around your home, both inside and out, to find good spots for photographing. Pick an area full of natural light and without too many distractions in the background. You want to avoid posters, mirrors, pictures, staircases, and any other bits of furniture or decor that take the focus away from your subject.

FRONT LIGHT: Illuminating your baby from the front is the most obvious way to use light. Start off this way, making note of shadows and what this light does to baby's facial features.

SIDE LIGHT: Now, turn or move your baby so the light no longer comes from the front but from the side. Again, keep an eye on shadows—if you can position your baby so both eyes are lit, try that. But also try light that comes fully from the side.

BACK LIGHT: This can get tricky but can also produce amazing results. Back lighting adds an amazing glow to hair and skin and creates a heavenly feel in the photo. Most photo books tell you to avoid such light. That's because sometimes it will cause an automatic camera to use the wrong exposure or focus incorrectly. To avoid either situation, try to use soft, diffuse light rather than hard, bright light with strong shadows. For example, if you used direct, hard light for the front and side light, lower the shade or move your baby to where the light is softer. Then carefully position the camera so your baby's face is filling the frame and the light is pouring over her from behind. At this close range, your camera should expose correctly. If it doesn't, try using exposure compensation (see page 64). Typically your camera may not give the scene enough exposure because the outside light causes the camera to judge the scene as brighter than it is. You can add exposure by using the "plus" mode of the camera's exposure compensation. Start with just a little and then keep adding to see how it changes the photo. If you back away from your baby, allowing more of the back light into the frame, you'll most likely need more exposure compensation to correctly light your baby, while everything around them will be very bright.

Once again, the trial-and-error method will be your friend. Take many portraits from different distances and with different lighting options. One of the most important aspects of portraiture is a good relationship with your subject. If you can get your child or your friend to smile or laugh or cry, you are already well on your way to creating better, more memorable portraits.

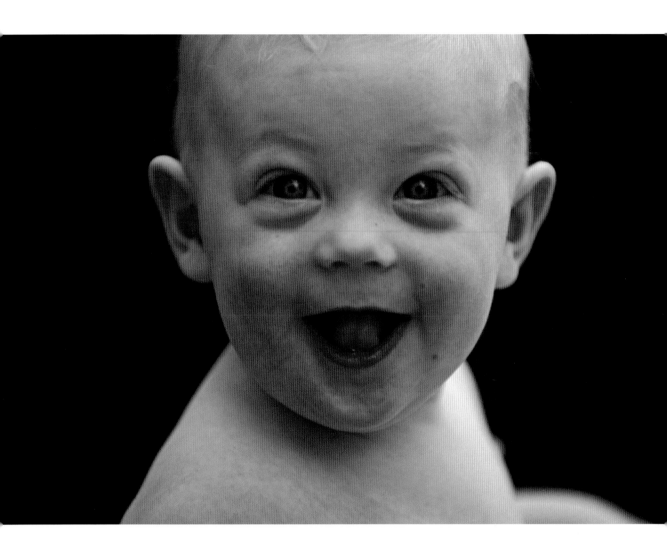

JOEL: When I look at this picture, I am reminded of how incredibly hard it is to photograph babies. I've worked all over the world in some of the worst conditions imaginable, been covered with insects, and sweating profusely. I'd STILL prefer that to trying to get a good picture of babies. They never hold still. If they look up at all, it's for a split second, and you're lucky to get anything that's in focus. Don't be frustrated. Keep trying, or you'll never get a graven image of your child.

WHAT IS EXPOSURE?

Exposure refers to the amount of light that reaches the film or digital sensor, and it's responsible for making the photograph. Too much light and your picture will be bright and washed out; too little and it will be impossibly dark. It's a lot like baking, where temperature and time expose the cake to heat. With a photo, it's the same concept, albeit with light.

A camera must be properly set to capture the light. The automatic setting on a camera allows it to make its best guess as to what a photograph should look like. But using an automatic setting means letting the camera interpret what you're seeing—and cameras are only so smart. In average lighting conditions, a camera's automatic setting can be quite effective. But if the light begins to veer away from average, you may want to change the exposure settings yourself.

Your camera works the same way your eyes do: If it's bright out, your pupils close down, letting in less light. Your camera's aperture acts as a pupil, letting in only a given amount of light. Its shutter opens and closes as eyes do. Together, the aperture and shutter speed expose the photo. If

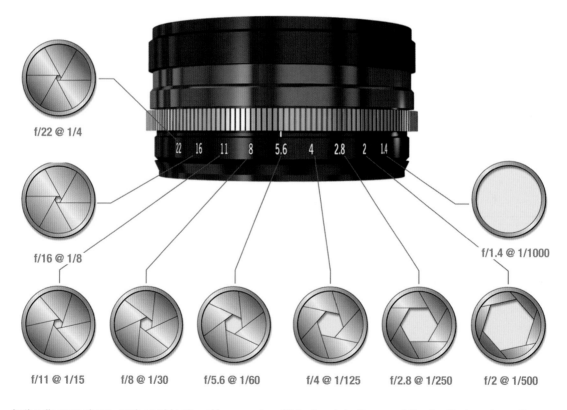

f/22 @ 1/4

f/16 @ 1/8

f/1.4 @ 1/1000

f/11 @ 1/15 f/8 @ 1/30 f/5.6 @ 1/60 f/4 @ 1/125 f/2.8 @ 1/250 f/2 @ 1/500

In the diagram above, each combination of lens aperture (f/stop) and shutter speed (the fraction) produces the same exposure, or lets the same amount of light into your camera. Experiment with each one to see what the change is in your photograph. You will see differences in movement and in depth of field.

both aren't correct, your photos won't be either.

Modern cameras can calculate exposure on their own. But if you know your camera, you can use its intelligence to lay the groundwork for more advanced shooting.

Most cameras function in three modes: fully automatic, semiautomatic, and fully manual. In fully automatic mode, the camera selects the ISO (or film speed), aperture, and shutter speed. You can take good pictures this way, but you won't have much creative control, and your camera may not always choose the correct settings.

To give you some choices, we divide using your settings into four separate categories: easiest, easy, advanced, and expert.

EASIEST: Use the fully automatic or "P." This offers the least creative control but the fastest and simplest way to use your camera.

EASY: Use a "scene mode"—all those settings labeled with the moon and stars, a mountain or a face. These let you tell the camera the kind of photo you want to take, rather than have it guess. These modes translate more advanced settings into situations you'll likely encounter.

ADVANCED: Use a semiautomatic "priority" mode.

EXPERT: Use your camera's "M" or fully manual mode.

ISO, APERTURE, AND SHUTTER SPEED

Three principles together manage exposure: ISO, aperture, and shutter speed. Even if you only plan to use automatic modes, understanding these will help you get the most from your camera.

ISO OR FILM SPEED: This is the sensor's or film's overall sensitivity to light. On a bright, sunny day, use a slower ISO setting, such as 100. Indoors, choose a setting of 400 or 800. A camera's automatic features will usually change this for you, but the quality of your photographs will be better with a lower ISO. Colors are more saturated and details are better preserved.

APERTURE: Think of this as how wide your camera's "pupil" is open. It controls the depth of field in a photo. A very wide opening (f/2) will mean very little depth of field (only your subject will be in focus), while a very small opening (f/32) will mean lots of depth (your subject, the foreground, and background will all be in focus).

SHUTTER SPEED: This is the speed at which the shutter opens and closes. Shutter speed freezes action (fast shutter speed) or blurs it (slow shutter speed). It is the most common culprit for blurry photos. You used too slow a shutter speed, and either the camera, the subject, or both moved at the time of exposure.

Individually, these settings are relatively easy to comprehend. But because they are dependent on one another, things get complicated. That's why cameras come with different shooting modes. They simplify things by allowing you to tell the camera what kind of picture you want to take.

JOEL: Following pages: I used a wide-angle lens here. The high angle is good for cleaning up the background, and I am right in her face with the camera. The combination gives a sense of who she is.

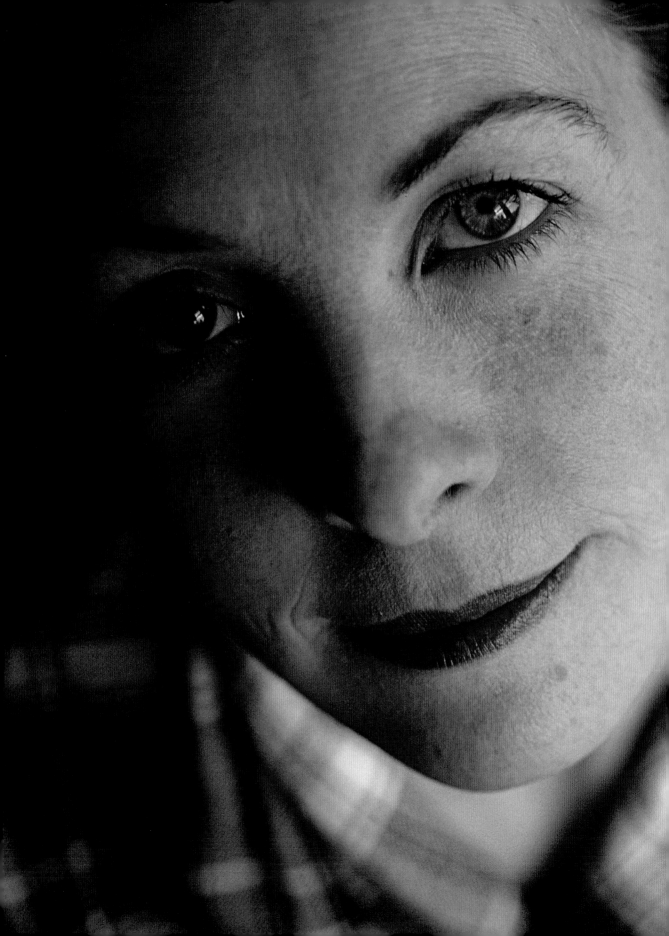

Camera Modes

As easy as manufacturers try to make it, camera modes are not always obvious. For example, who would know that a P with a green square around it means fully automatic? But it does. And in your camera manual, you may see the acronym AE showing up a lot. It stands for automatic exposure, and it signifies that the camera—not you—will be setting the exposure. Inside is far darker than outside, something most people don't realize because their eyes quickly adjust when they go from one to the other. This setting will generally use a higher ISO speed and change other settings so more of the available light inside is used, rather than only relying on flash. This makes a more natural-looking photograph.

Easiest: Fully Automatic

Often a capital "P" (sometimes it's green or will have a green square around it) on the camera's mode setting, this tells the camera to set the ISO, aperture, shutter speed, focus, and flash modes and all other settings. It tends to be a safe mode that will produce sharp, well-exposed photographs, but it will be at the expense of the creativity different settings can offer.

Easy: Automatic Scene Modes
Portrait:

This setting will choose a wider aperture (a smaller f/number) to reduce the depth of field so faces won't compete with their surroundings for attention. It may also change the exposure settings so the faces are exposed correctly, in preference to the rest of the frame.

Action/Sport:

When you want to shoot a football or tennis player in motion, you need a fast shutter speed to freeze the action. The camera's "action" mode will change the other settings to ensure its shutter speed is over 1/500th of a second.

Landscape:
This setting is the opposite of portrait. It's de-

signed to reduce the size of the aperture (a larger f/number) so as much of the scene as possible is in focus.

Night:

This setting will raise the ISO and lengthen the shutter speed so more of the available light at night will be evident. Without this mode, there might be no details around the people or places you are photographing, except for what the camera's flash captured. By combining a longer shutter speed and a flash, you can more accurately capture nocturnal atmosphere.

Advanced: Priority Modes

These are still automatic modes, but they allow you to set either the shutter speed or aperture yourself. The camera then determines the other setting on its own. Often the camera will not change ISO automatically using these settings.

Aperture Priority:

Usually an "A" or "Av" on the dial, this automatic setting lets you pick the aperture; the camera will automatically choose a corresponding shutter speed to correctly expose the scene. This is a good setting if you want to control the depth of field of a photo by selecting either a small aperture number (for little depth of field) or a larger

aperture number (for greater depth of field). The Av stands for "aperture value."

Shutter-Speed Priority:

Usually a "T" or "Tv" on the dial, this setting is the reverse of aperture priority. You pick the shutter speed, and the camera selects the right aperture for your scene. This comes in handy when you want to pan a shot using a slow shutter speed (say 1/30th or slower), or if you want to freeze an image using a very fast shutter speed (over 1/500th of a second). The Tv stands for "time value."

Expert: Manual

Usually an "M" on the dial or menu, this mode lets you set the ISO, shutter speed, and aperture. The camera will not make any of its own adjustments to these settings. Typically, you should use the camera's light meter to adjust exposure based on how you want the photograph to look.

Beyond the Basics

As you get comfortable with your camera, you may want to experiment more. Just as a cook might tinker with a recipe to get it just right, a photographer can adjust the camera settings to create the perfect image.

For example, when shooting a picture of your child blowing out birthday candles, your camera's automatic mode might ruin the scene by using harsh flash. An advanced beginner may recognize this and select the indoor mode, which will preserve the candlelight and perhaps also add a bit of flash. An advanced photographer would take it one step further: Recognizing the need for a higher ISO, she would set it to something around 400, or 800 depending on conditions. Then she would turn off the camera's flash and choose a priority mode to set either the shutter speed or aperture.

When making such adjustments, it's important to remember that a wider aperture or slower shutter speed make camera shake all the more obvious. In such situations, you might want to use a tripod or other means of holding the camera steady to avoid blurry photos.

This may sound complicated, but here is a simple step-by-step list of things to think about:

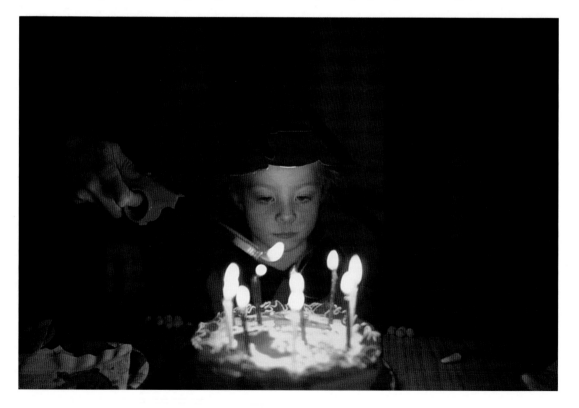

JOEL: *In this picture, we are letting the candles light the subject. I used a spot meter on her face to give me the exposure. The ISO is turned up to 400 and the shutter speed is 1/60 of a second.*

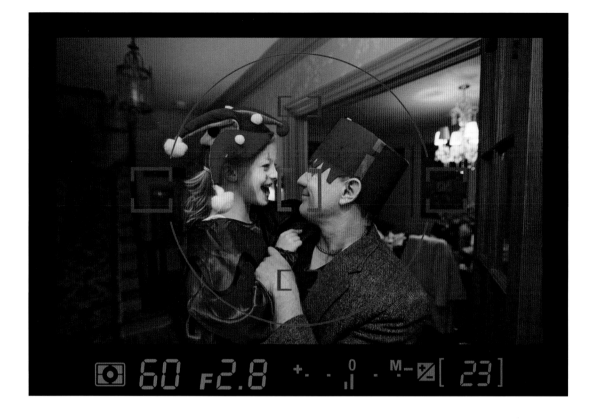

JOEL: The shutter speed is slow to soak up some of the colors in the background in this picture. I used a tiny bit of flash bounced against the ceiling to freeze us and limit any blur in the photo.

1. Set the ISO: It affects all the other settings, so adjusting it first will simplify the next steps
 - 100 for bright daylight
 - 200 for moderate amounts of light
 - 400 or 800 when indoors or at night
2. Do you want to use flash? If not, make sure it's turned off.
3. Select a priority mode.
 - Is depth of field important? Choose aperture priority mode (A or Av).
 - Is freezing action or intentional blurring important? Choose shutter priority mode (T or Tv).

Of course, aperture and shutter work closely together, so remember that you are setting only one. The camera will set the other for you based on what it believes is the correct exposure.

Internal Meters

Most cameras have internal meters that measure the light being reflected off the subject, and this is the basis for its automatic exposure. The computers inside the camera are also programmed to assume that most objects and/or scenes are an average brightness and color value. This average value is a concept known as "middle gray," and it's why exposure-compensation and average modes are included with better cameras.

While their internal computers are quite good at guessing a scene's brightness, there are many times when the exposure—if compensated or set manually—will help your photograph look perfect as opposed to muddy (too little exposure) or blown out (too much exposure).

Cameras will often have a meter that's shown within the viewfinder or display when the camera is set to a priority or manual mode. In priority modes, the meter can be used to dial in exposure compensation (which I explain a little later in the chapter). When photographing a bright subject, you may want to add additional exposure to brighten the scene around it. Using the camera's controls, you can add exposure using the meter as a guide. The meter will show exposure in increments known as "stops."

Understanding Stops

Shutter speed, aperture, and ISO are universally standard values found on cameras. Each value can increase or decrease in increments known as "stops." When you move one of the values, the other two are affected.

For example, let's say you take a picture at 1/250 second at f/8. A two-stop brighter change in that exposure could be made by either slowing the shutter speed by two stops, opening the aperture by two stops, or by a combination of slowing the shutter speed one stop and opening the aperture by one stop. You could also turn the ISO value up by two stops and leave both the shutter speed and aperture alone. The net result for all of these is that the picture is brighter by two stops, but each will have its own visual effect on the final photo. A slower shutter speed may blur the subject more, a wider aper-

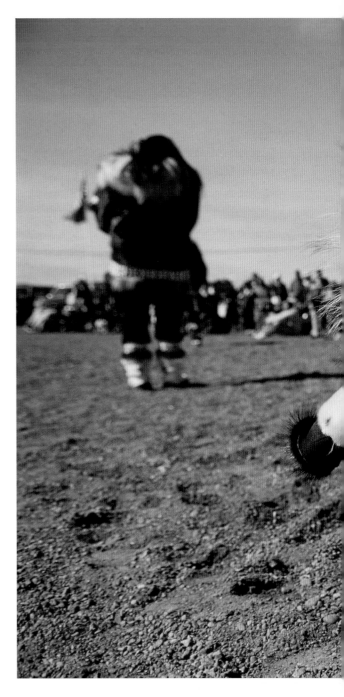

ture will mean less depth of field, and increasing ISO will mean less picture quality.

See the following sidebars on changing stops for more in-depth explanations on how each will affect your photos.

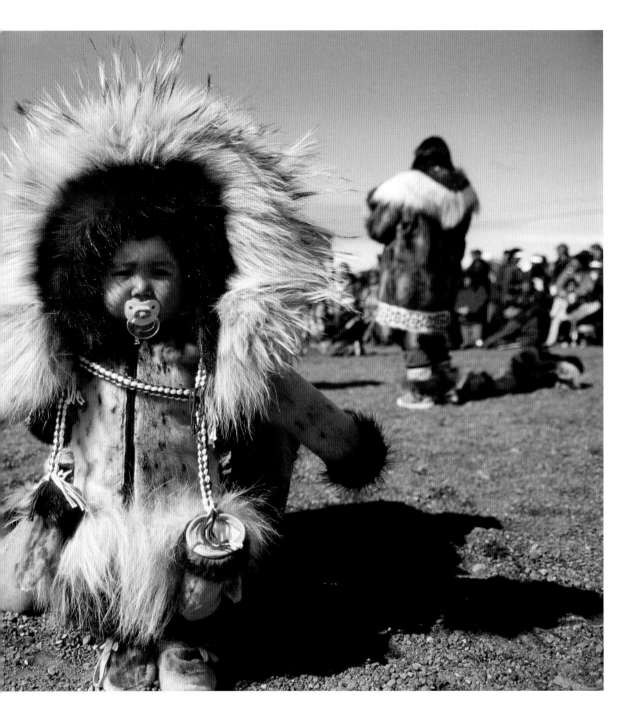

JOEL: *I took this picture at a baby contest in Barrow, Alaska. It was a bright day, and it was an event in the middle of the day. The light was harsh. I knew I wanted to imply what was going on in the background, so I needed more depth of field. I set the camera at f/8 with a low ISO to reduce any noise or grain in the picture.*

Equivalent Exposures
Changing Shutter Speed

These three photos show how shutter speed changes the look of an image. Notice how the water differs in each. In the first photo, a slow shutter speed causes the water to blur completely. The second photo's medium shutter speed makes the water slightly blurry. But in the third photo, a fast shutter speed stops the water almost completely. All three exposures use the same amount of light but differ in how they use that light.

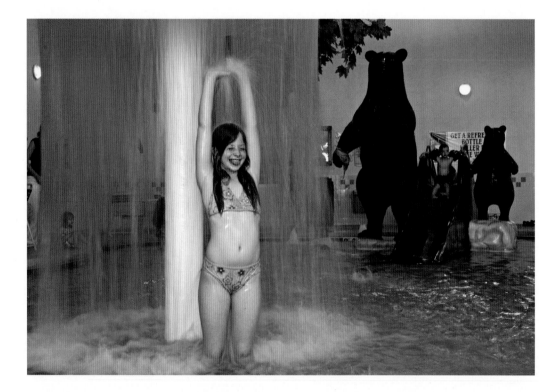

This photo uses a slow shutter speed of 1/15th of a second to blur the moving water. The correct aperture setting is f/16 at ISO 400. To view the relationship between the three components of exposure, see the stop chart, at right. Each line represents a stop on each chart. A one-stop faster shutter speed would be 1/30; a one-stop wider aperture is f/11.

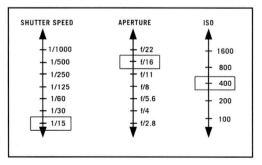

SHUTTER SPEED	APERTURE	ISO
1/1000	f/22	1600
1/500	f/16	800
1/250	f/11	
1/125	f/8	400
1/60	f/5.6	200
1/30	f/4	
1/15	f/2.8	100

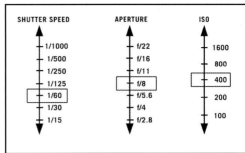

Above, a faster shutter speed of 1/60th of a second almost freezes the water. Because a quicker shutter speed lets in less light, the aperture must be wider to let in more light. Therefore, we chose a setting of f/8.

Notice on the graph that the shutter speed changed from 1/15 to 1/60th, a difference of two stops. To keep the exposure the same, aperture was changed to let more light in, to f/8. The ISO was kept the same.

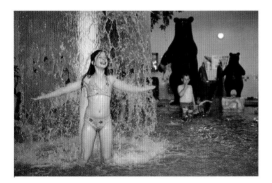

Now, let's say we want to freeze the water completely with a shutter speed of 1/500th of a second. Notice what the corresponding aperture setting would have to be to maintain the same amount of light: f/2.0. That's a very wide aperture available only on expensive lenses. Instead, we raised the ISO setting. This allows a faster shutter speed and a higher aperture because the camera is now more sensitive to light. Why not always use a higher ISO? Because as the ISO increases, the quality of the photo degrades. The colors may get murky, and the picture loses its fine tones, textures, and detail.

The shutter speed in this example increased three stops to 1/500, but because aperture value could not be below f/2.8 (the lens didn't offer that setting), the ISO setting was raised one stop. Thus the exposure remained the same and a faster shutter speed was used to freeze the water.

Histogram

The preview of your image on the LCD screen on the back of the camera will give you a general idea of picture quality, but it leaves a lot to the viewer's discretion. Most digital cameras will show you a histogram, which allows you to judge the exposure based on a graph of the quantity of dark, middle, and light tones found in an image. A nicely exposed photograph will have detail throughout the darks, the midtones, and the bright areas; and the histogram will confirm that this is or isn't the case with your photo.

The left side of the graph represents black and dark tones (the left-most side representing pure black), the middle represents the mid-

tones, and the right the light tones and whites (the right-most side representing pure white). A properly exposed photograph will keep all of these values generally within the middle two-thirds of the graph. An underexposed photo—one that is too dark—will have all of its data on the left side of the graph, while an overexposed (or too light) photo will have most of its data show up on the right side of the graph.

There are exceptions to this. A dark, night-time scene will have much of its data appear on the left side of the graph, while a bright scene will have its data mostly on the right side. That's okay, so long as the graph doesn't pile up on the extreme right or left side, meaning there is noth-

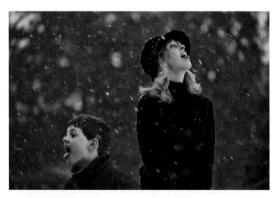

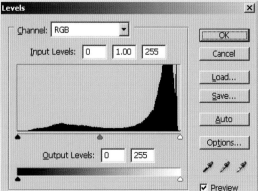

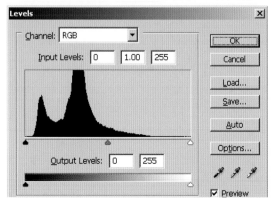

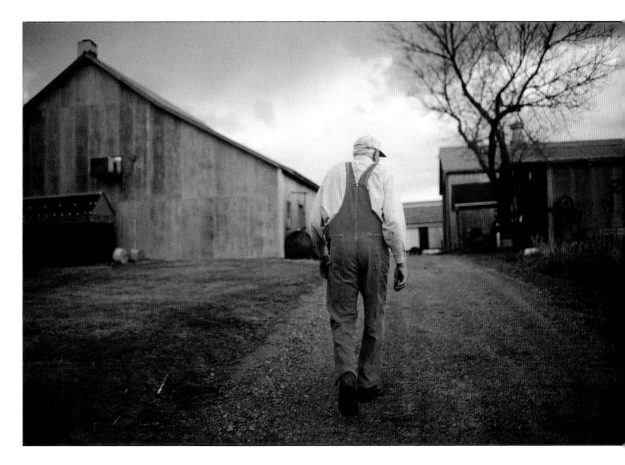

JOEL: *Left: Two snowy scenes, opposite tonalities. The bright scene will have more information on the right side of the histogram; while the darker picture with snowflakes will show a histogram skewed left.*

This page: Fairly even in tonality, this photo's histogram will be center.

ing but pure black or pure white in the picture.

These phrases will help you use histograms to make good exposures:

Right is bright (the right side of the histogram shows the number of bright pixels in the image). Keep the mountain in the middle (most of the information should be in the center of the histogram, not crowding either side). Don't clip the highlights (don't crowd the right side of the histogram or you'll have blown-out highlight detail you can never get back).

Remember these are general guidelines. If you're photographing something dark, your histogram will hug the left for dear life. If you're photographing something white in the sun, the opposite will be true.

Exposure Compensation

Exposure compensation sounds intimidating but is fairly easy to master. Because the camera may not expose a too dark or too light scene correctly, you can adjust the automatic settings to increase or decrease the exposure (let in more or less light).

For example, a child sitting on the hood of a black car may be overexposed because the camera assumes the whole scene is dark, not just the car. Turning the exposure compensation down one to one and a half stops tells your camera to set the shutter speed or aperture to allow in less light and more properly expose the photo.

The same applies when photographing something bright—someone on a sunny beach. Increasing exposure compensation tells the camera the subject needs more light.

Remember, brighter scenes generally need more exposure, darker scenes need less. If your image is coming out too dark, set the exposure compensation to a positive value. If it's too bright, set it to a negative value.

Exposure compensation is almost universally referred to by the same symbol: +/-. Point-and-shoots use a menu on the camera's LCD screen. Higher-end cameras and 35mm SLRs have a dedicated exposure-compensation button or let you depress the shutter button halfway and adjust a knob or button on the back of the camera.

JOEL: These are flamingoes at the Lincoln Children's Zoo in Nebraska. Most of the time I don't use exposure compensation when fine adjustment is necessary; I try to set my camera manually. I want to craft the picture myself.

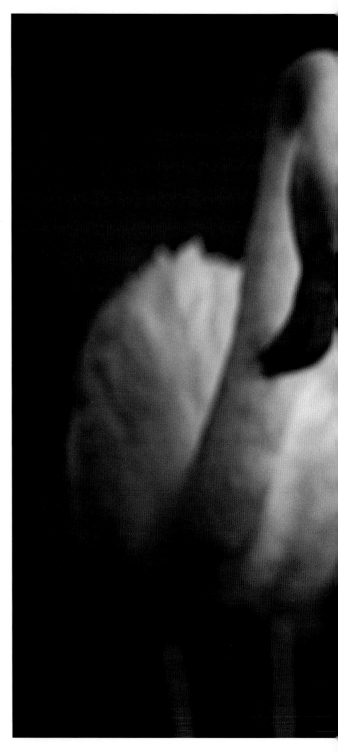

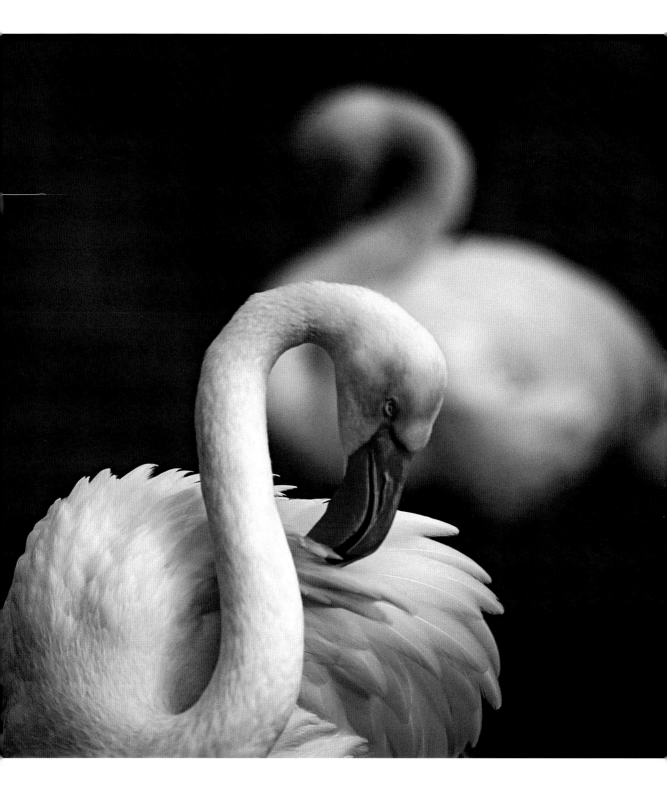

Aperture Priority

When you want to control how much of your image is in focus, you need to manage your depth of field. Depth of field is dependent solely on the aperture you select. Again, the wider the aperture (and smaller the f/number), the less depth of field your photograph will have. A lesser depth of field limits the focus area to just your subject, leaving objects in the foreground and background out of focus—handy for removing distracting visual elements.

Your camera may have a mode where you set the aperture value, and it sets the corresponding shutter speed to expose the photograph correctly. This is known as "aperture priority," or AV. Experiment by changing the aperture from its lowest setting (usually f/2.8) to its highest and notice how the shutter speed changes. But be careful, setting too high an aperture can result in a shutter speed too slow to take clear photos without a steadying tripod. Sometimes, setting too low an aperture can result in the camera not having a fast enough shutter speed to correctly expose the photo, leaving it overexposed.

Say you're shooting a white dog in direct sun—a very bright scene. On aperture priority mode, the camera may show an exposure setting of 1/500th of a second at f/11 and an ISO setting of 200. But you may want to increase the exposure by one stop to brighten up the scene. Remember, your camera assumes this very white scene should be middle gray, and it will set the exposure so it shows up that way when you snap the photo. To increase the exposure one stop, you could switch to manual mode and do one of the following: Open the aperture to f/8 (which is a bigger opening than f/11, thus letting in more light); decrease the shutter speed to 1/250th of a second (a longer time lets in more light); or finally, you could leave the camera settings alone and change the ISO setting to 400. (Changing the ISO setting isn't convenient and should generally be a last resort. But here it's used to show how the three settings are interrelated.)

Don't be afraid to use the aperture-priority setting on your camera. It really saves time. If your camera is set on the aperture-priority mode, most of the time you'll get a good exposure quickly without too much thought. If the situation will last a while, switch to manual and make the scene lighter or darker. Remember, your primary goal in photographing your kids should be to capture fleeting moments that won't come around again. The aperture-priority mode will do that for you at least 90 percent of the time.

APERTURES WITH LESS DEPTH OF FIELD	APERTURES WITH NORMAL DEPTH OF FIELD	APERTURES WITH MORE DEPTH OF FIELD
f/2.8	f/8	f/16
f/4	f/11	f/22
f/5.6	f/16	f/32

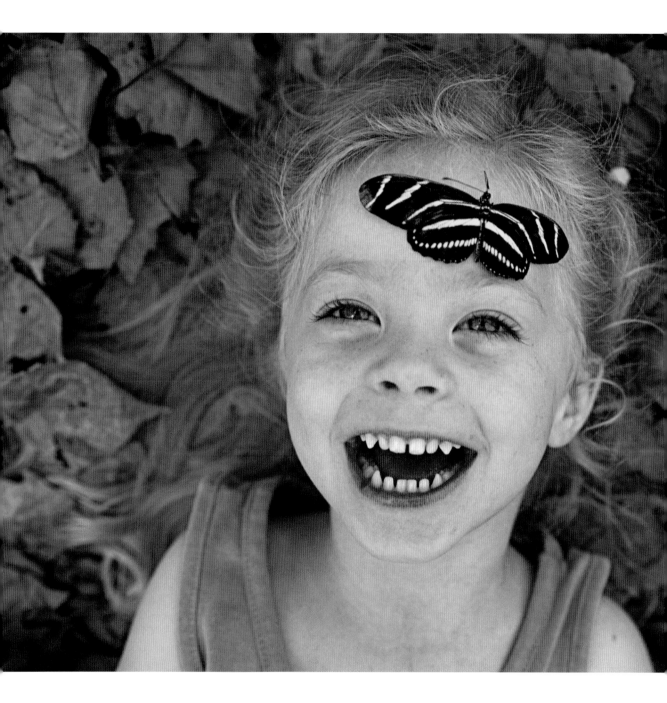

JOEL: *This is Ellen at the Lincoln Children's Zoo. Besides trying to get the scene evenly lit and the shutter speed fast enough to freeze her movement while she's laughing, I was worried about the depth of field. I walked a fine line using depth of field to make sure the butterfly and facial features were sharp, while keeping the shutter speed fast enough to freeze the action and not render the frame a blurry mess. I don't care whether the leaves in the background are sharp. In fact, it's probably better that they're not because they're less distracting.*

Equivalent Exposures
Changing Apertures

As with the shutter-speed examples, I took three photos of the same scene. This time, using aperture priority, I set three different f-stops: f/4, f/8, and f/16. The ISO remained set at 400, and I let the camera set the correct shutter speed for each aperture.

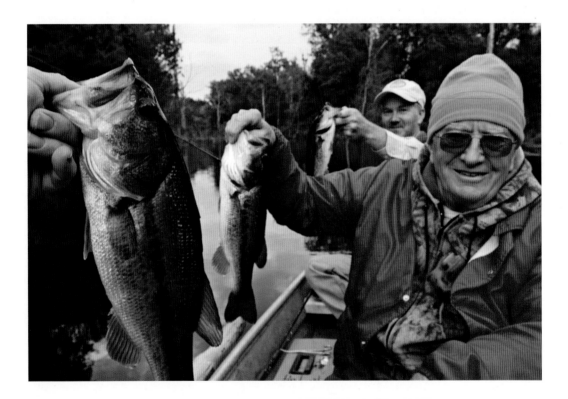

This photo works best of the three because at f/16 there's enough depth of field to make most everything in the boat sharp. But when you use a very small aperture, your shutter speed will decrease considerably to keep the scene bright enough. Be sure to hold as still as possible or you'll get a blurry photo.

SHUTTER SPEED	APERTURE	ISO
1/1000	f/22	
1/500	**f/16**	1600
1/250	f/11	800
1/125	f/8	**400**
1/60	f/5.6	200
1/30	f/4	
1/15	f/2.8	100

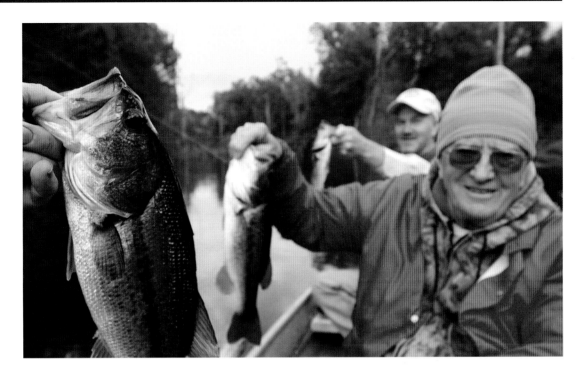

I used the aperture f/8 for this photo, so the shutter speed sped up somewhat in order to make the correct exposure. Notice how the fishermen are starting to become out of focus as the aperture opens up a bit.

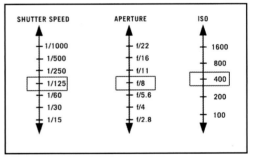

I'm using an aperture of f/2.8, and the fishermen are very out of focus. This image is the least successful for me because I want to see my dad and brother, not to mention the nice fish we caught.

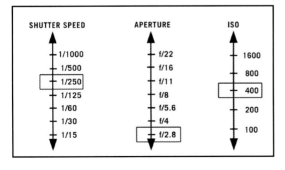

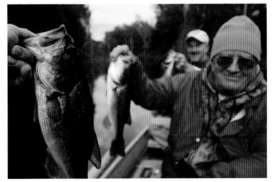

Shutter Speed Priority

The shutter-speed setting determines how long the shutter remains open to allow light to enter the lens. You already know how aperture can make a photograph look different. So how does shutter speed change a photograph? Shutter speed is the common culprit of one really annoying problem: blurry photographs. These happen for two reasons: camera shake or a subject that moved during the exposure. The first type of blur, camera shake, happens simply because the camera was jostled while the shutter was open. If the subject moved during the exposure and the shutter speed wasn't fast enough to freeze it, the subject will be blurry. You'll often see this in group photos taken with a slow shutter speed. The serene relatives who stood still won't be blurry, but the jokesters who were laughing and clowning around will be. So how do you fix each situation? Simple. Use a fast shutter speed.

A slow shutter speed can also be a fun, creative technique if you're careful. Sometimes, having your subject blurred adds a great sense of movement to a photograph. Photographing a child jumping for joy or chasing a pet can use blur to great advantage. With a slow shutter speed and a judicious hand, your exuberant subject will be blurred while the background remains crystal clear.

Again, restraint is the key. If both the camera and the subject move, the background will not come out clearly in the final photograph, and the effect will be lost.

On the other hand, moving the camera can also produce a great effect. Try something called panning. When you pan, you use a relatively slow shutter speed and intentionally move the camera at the same speed as the subject is moving. When the camera and the subject move at the same speed, there's no net movement between the two, and the subject remains in focus. Everything else in the frame that didn't move, however, will be blurry. Your photo will convey motion, and you'll have a great shot of your speed demon whizzing past a virtually indistinguishable background.

It's a cool effect and worth some experimentation. For a child toddling across the room or taking a first spin on a two-wheeler, you may try a shutter speed of 1/30, 1/15, or 1/8 of a second and move your camera carefully along with your child.

It will take some practice to get panning right. Until you've gotten comfortable with the movement, try not to stand too close to your subject. The closer you are, the more precise you'll need to be. Better to stand a bit farther away and reward yourself with good pictures.

To change the shutter speed on your camera, look for a shutter-speed-priority setting. This is like the aperture-priority setting except now you are setting the shutter speed and letting the camera pick the aperture. This setting is commonly the "T" or "Tv" setting, an abbreviation for "time" or "time value." See the sidebar for tips on how this can change your pictures.

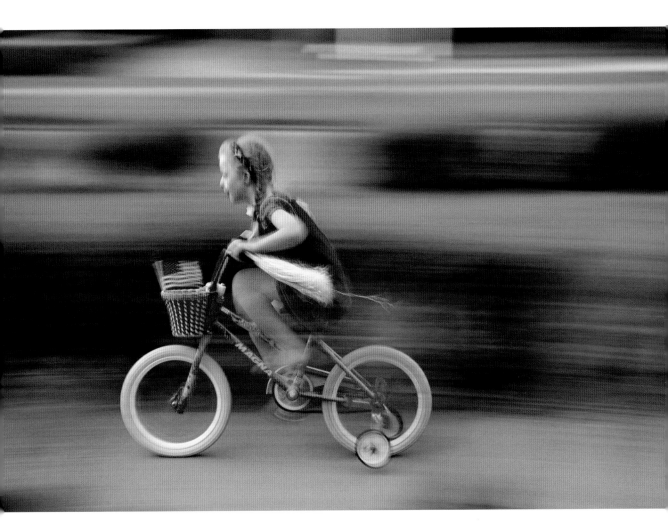

JOEL: *Panning is very easy if you have people moving at a predictable speed. You're better off if you are stationary and you follow through nice and steady. Here, the light is late and even, and I am shooting at 1/15 of a second at f/8. You want the lowest ISO possible because there is no reason not to. You'll have plenty of light hitting the sensor because of the slow shutter speed.*

SLOW SHUTTER SPEEDS	AVERAGE SHUTTER SPEEDS	FAST SHUTTER SPEEDS
Use these speeds to intentionally blur or pan a subject, or avoid them to minimize blur	These are safe speeds to use when you are photographing most "average" subjects	These are good for freezing action
1/4 second	1/60 second	1/500 second
1/8 second	1/125 second	1/1000 second
1/15 second	1/250 second	1/2000 second
1/30 second		

The evening sky silhouettes the swings at the State Fair in Lincoln, Nebraska.

Chapter Two
MORE ADVANCED TECHNIQUES

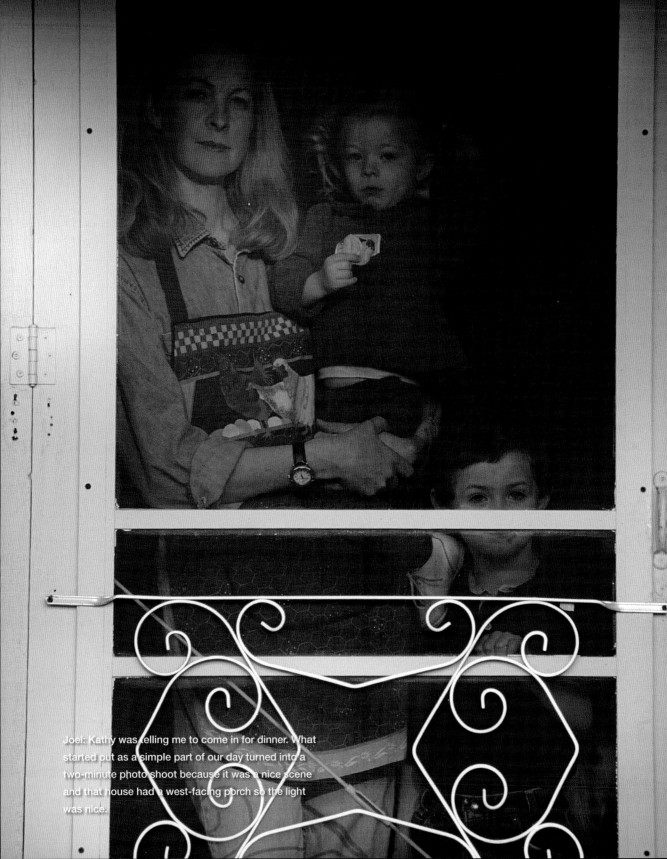

Joel: Kathy was telling me to come in for dinner. What started out as a simple part of our day turned into a two-minute photo shoot because it was a nice scene and that house had a west-facing porch so the light was nice.

MORE ADVANCED TECHNIQUES

Good photography—like music, painting, or poetry—doesn't happen overnight. Granted, when you're taking pictures you can get lucky once in a while. But take the time to make mistakes and experiment. Be open to the possibility you may not always get pictures you like. You will find many examples of favorite family images in this chapter—and a few mistakes.

One thing to note is how little the flash is used in any of these pictures. Light from a flash comes from an unnatural source and looks it. Just as a deer doesn't look too attractive in a car's headlights, people don't always look so great when lit directly from the camera. The details of how to use a flash can also get rather technical, and because of this it's best to concentrate on other areas of photography where your efforts can make more of a difference. (See Chapter Five for a few pointers if you must use a flash.) Many professional photographers who are experts with flash will still avoid using it whenever possible. You should, too.

Simple Moments

Your eyes quickly adjust to indoor lighting, so it's hard to understand just how much darker it is indoors than outside. But it is a lot less bright, even with all the lights turned on. In most instances, you almost always have to use a higher ISO indoors—especially if you aren't using flash.

A typical setting for either of these photographs would be 1/60 of a second at f/4 and an ISO 400. The 1/60 of a second shutter speed is fast enough both to freeze the people and to keep camera shake from blurring the photo. If your lens does not open up to such a wide aperture, then you must use a higher ISO setting to compensate.

JOEL: Ellen was looking cute. Kathy had just taken a shower, so I asked her to snuggle up behind Ellen and kiss her on the cheek. I have the camera on the widest aperture possible, autofocus, and no big production.

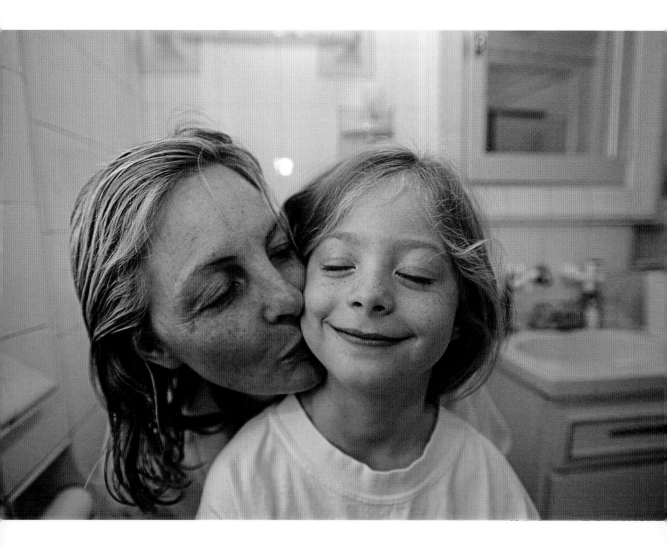

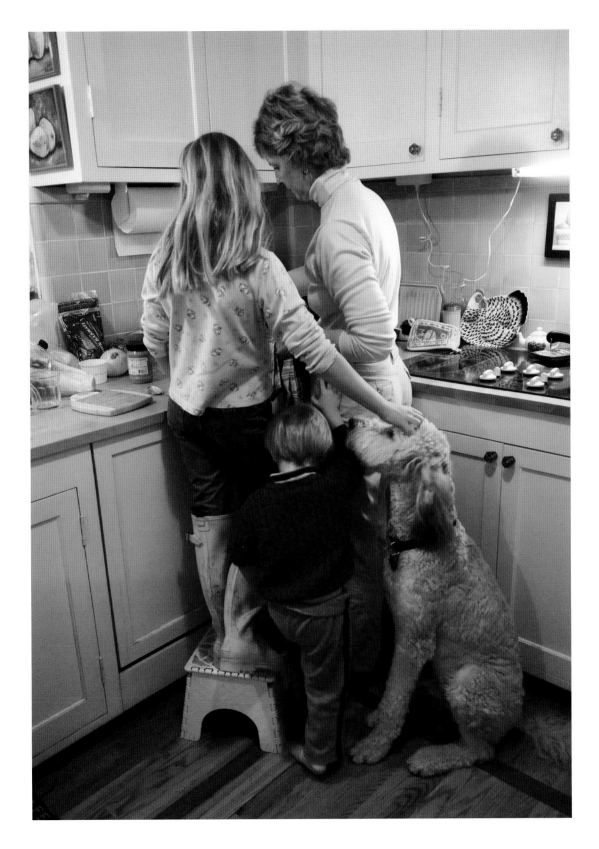

Country Road

Landscape photography is all about the right vantage point, the right time of day, the right elements in the photo, the right equipment, and, most of all, patience.

This picture was made with a "long" focal length lens, which generally is a lens at least 150mm in length. By using such a lens you can bring foreground and background elements visually closer together. For instance, if you look at this scene without a camera, the truck would appear much further in front of the background hills. Looking through a long lens will make the telephone poles in the background appear to be much closer to the truck, a concept known as "lens compression."

If you have a zoom lens, try this exercise: Frame up a line of cars or fence posts. Look at the scene with the zoom set at about 50mm or 80mm. Then, move farther back and zoom as tight as possible. See how much closer the fence posts or cars look to each other. This is a little trick photographers use quite often.

JOEL: This picture is about the background. I've seen that scene driving home from my farm over and over and I just never thought about shooting it. It was a chance to do a layered picture in nice light. I used the aperture to control how much distraction I had in the picture. If the road is clean enough, you can shoot with some depth of field. If the road is distracting or there are things in the background, then you could shoot wide open, at f/2.8. The frame is a bit loose for me, meaning there's too much sky. I'll do it better next time.

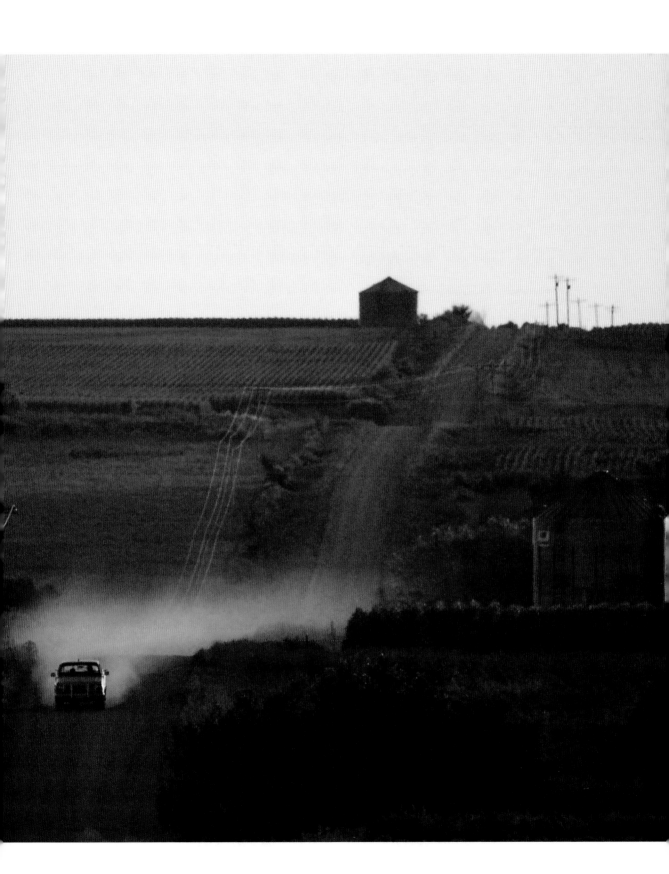

A Cold Day at the Parade

This is one of the few black-and-white photos in the book. Black-and-white photos let your mind focus on the shapes, forms, and subject matter of the photograph rather than the color, which can easily overwhelm a picture. In a picture like this, you can come in close and used a limited depth of field by selecting a smaller aperture number, about f/4 or so. A few tips: All lenses have a limit of how close you can get and still focus. So if the camera won't focus, you're too close. Also, when you use a longer lens and zoom in, the background tends to go out of focus more than if you were using a wider lens at the same aperture. If there are a lot of details in the background you would like to minimize, a longer lens and a smaller aperture number make a great combination. Sports photographers use this formula often.

JOEL: *It was December and miserably cold. That's Ellen when she was two or three years old, and she was freezing. Kathy was comforting Ellen, who didn't want to leave because the parade was coming. My motto is: If they are laughing, shoot it; if they are crying, shoot that, too. Shoot first and ask questions later. Of all the pictures I take, the crying ones are the most fun to look at. You never see people shooting their kids crying, ever. My kids cry every day, at least one of them. I think all three cried yesterday. How can you not photograph that aspect of your life? You're cheating yourself if you're not photographing everything.*

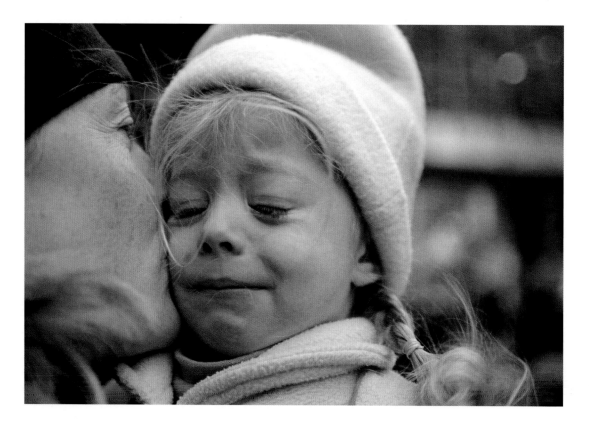

Household Chores

This looks like a simple picture, but several decisions in advance helped to create its simplicity. The first was the choice to make the picture horizontal. A vertical frame would have lost the subtle details of chaos surrounding the characters (including Cole's younger sister, Ellen, dancing in the background). Next, the decision to make the picture in black and white to minimize the colorful clutter and focus on Cole and Kathy emphasizes the actions in the picture and not the surroundings, which might have overpowered the scene. There was no flash; an overhead light in the kitchen was the only source of illumination. Flash, as it so often does, would have made the light look artificial and ruined this photograph. When shooting something similar, turn the flash off and raise your ISO to 400 or 800, then try a setting of 1/30 of a second at f/4, increasing the ISO as necessary to get a shutter speed of at least 1/30.

JOEL: That's Cole, and he doesn't want to get his hair cut because he wants to be cool, and I'm too cheap to pay a barber. Kathy knows how to cut hair. I once traded a lady pictures of her family for hair cutting lessons. Cole just doesn't like his hair cut because the style in his school is to have really long hair. But the kids go to a Catholic school, and the principal doesn't want boys with hair down to their knees.

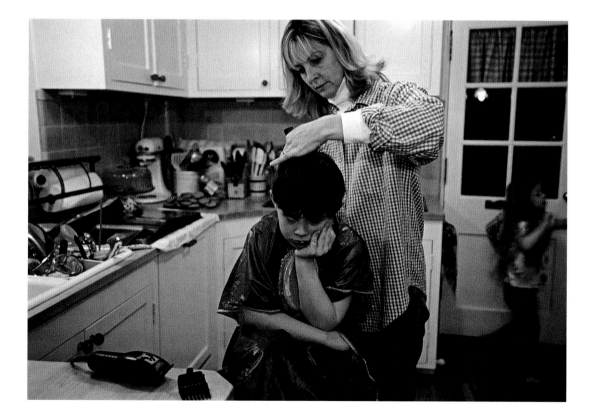

Family Portraits

There are three basics to a family portrait: something to hold your camera, a self-timer, and a nice "stage" with good light.

A tripod makes positioning your camera easy, but choose one that's small and lightweight so you don't mind carrying it with you. Or, you can improvise. Photographers use everything from a car's hood to a ladder or a bag of beans to stabilize a camera.

Your camera's self-timer is the mode with the little clock symbol. Remember that you still have to focus and expose the scene correctly. Most cameras will do both for you with a half-press of the shutter button when set on an automatic mode with the timer. A full press then activates the timer. If possible, have someone pose for a test shot to see how the picture looks. It may help to read the manual beforehand so you know exactly how your camera's timer functions.

The last element is the "stage," similar to the concept of a theater stage. Set designers create sets that are appropriate to the action in a scene. Similarly, you should be looking for the right place to take a photograph. Don't just accept the first available spot. A painter certainly wouldn't and neither should you. Be picky. Search for the warmest light and an appealing, clean background. If the background is a bit busy, arrange everyone as far from it as you can and choose a smaller aperture number to blur it out. (Remember, a smaller aperture number equals a larger opening, which gives you less depth of field.)

Here are two examples that required two different approaches. The top photograph is an Easter Sunday portrait. At bottom is a portrait of Joel's family the first time they took their third child to visit Joel's grandmother at the nursing home where she lives.

JOEL: (top right) Easter Sunday is the day when families are supposed to get a picture of themselves—one of the few times when we all get dressed up. The light is terrible; it's backlit, very flat. I needed to shade the lens more. It's a good example of what happens when you're in a rush and you're using a self-timer. Technically, it's not a very good photograph and it's not a very interesting photograph, except for the fact that we all look very happy and formal, yet Spencer is screaming. That's the only valuable part of the picture.

JOEL: (bottom right) We made sure my grandmother was next to a window. She hadn't held Spencer very much, and her health was failing. Wherever you are you try to find the place that's the best-looking for a photograph. Where's the stage in life and where do you put the players? If we're outside, we're looking for the direction from which the light looks best—in open shade, where the light won't be hard or where it will be subtle. In a fluorescent-lit nursing home reception room with a low ceiling, the only time it looks any good is when you shut off the room light and position the people over by the window. It's a more graceful light than fluorescent strips overhead. You could just put your camera on a fluorescent-bulb setting and shoot available light in the room, but it just won't look as good. Also, people tend to get dark shadows under their eyes if you don't have a sidelight source. Rembrandt knew this—just look at the sidelight in all of his paintings.

Dinner at Home

This is a picture that would have been difficult to do with film but is quite easy with digital. There are several types of light in the frame, each with its own color: green fluorescent, blue evening light, and a yellowish tungsten bulb overhead. A digital camera's auto-white-balance setting will handle all of these types of light nicely. Remember, no flash! Keep your ISO setting high (400 or above) and keep a steady hand (your shutter speed will probably be slow, around 1/60th at f/5.6-f/4.0).

JOEL: *If you think about a lot of the work that painters have done through the centuries, a lot of it is really common stuff. When I was a kid I would wonder why in the world would someone paint a picture of an old guy praying over a loaf of bread or people standing there taking a break from cutting wheat by hand. There is a lot of stuff that is common in historical paintings—religious themes, battles, or people just doing everyday things—in good light. For me, something that never gets shot—say a woman doing dishes—is actually well worth doing. You just never see well-done pictures of people actually living life, unless it's cheesy stock pictures of obscenely good-looking couples and kids pretending to have the time of their lives on a barren white beach somewhere. Most beaches are crowded and filthy, and real people don't look like that. If I see something interesting happening in nice light—if the scene looks good—hopefully I recognize it and shoot it.*

Thanksgiving

Environmental portraits, as they are known, are photos of people that give you both a good idea about them and also about where they are. When taking someone's picture, ask yourself how important the environment around them is. Including it can help give a sense of completeness to a picture.

Try opening up the aperture to a smaller value of about f/5.6 and focusing on your subject. When you do this, the background loses focus just enough to highlight the distinction between subject and environment. See how the house is a tiny bit blurry? This helps Joel's mom and her turkey—crisply in focus—*pop* from the scene, and thus remain the central point of the photograph.

JOEL: The light is awful in my mother's kitchen. It doesn't have any natural light, and I was too lazy to get my flash out. I asked her to come outside where we could get a good picture. You'd never haul a turkey outdoors. She didn't want to. She wanted to take her apron off and fix her hair. I said "No, no, no! Let's haul that turkey outside and get this done. Quit arguing with me and it'll happen a lot faster. It'll be over with." Now she really likes the picture, but at the time she was really embarrassed because while we were out there the neighbor yelled out, "Sharon! That turkey has got to be either really good or really bad!"

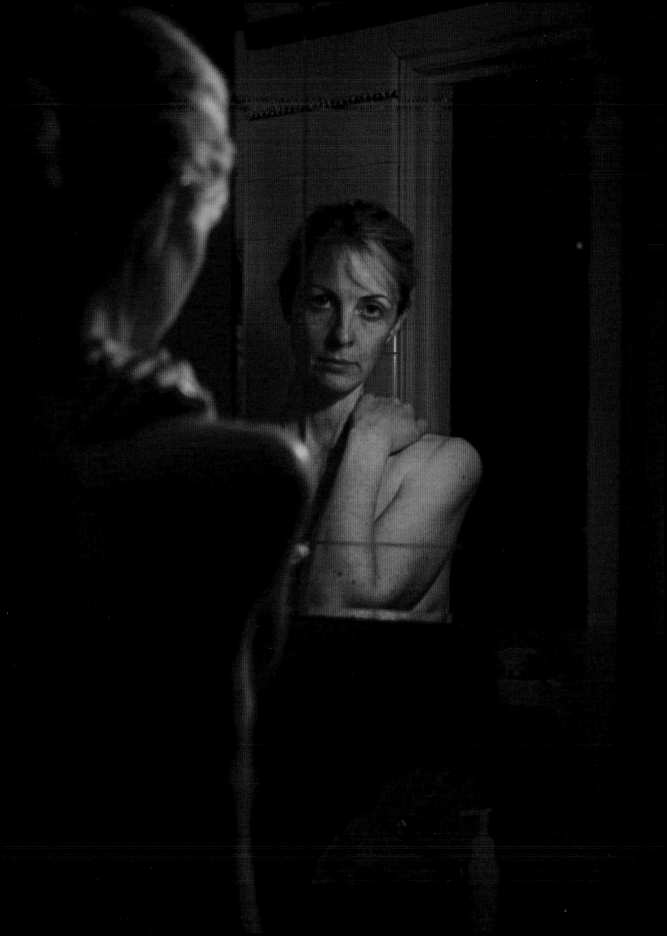

Low Light

You can't always find a setting with perfect light, but often, settings with very little light can yield wonderful photographs.

To make a picture like the ones here, you'd want to turn your flash off, set a higher ISO setting so the exposure comes out correctly, and use the widest aperture (smallest aperture number) your camera has. Also, experiment with not using the auto-white-balance setting on your camera. Instead, turn it to its "daylight" or "cloudy" setting, which will make a tungsten light turn very warm. Often, auto white balance will remove much of the warmth of household lightbulbs and turn a scene too cold.

The light in both of these photos is a similar color, even though it comes from two very different sources: a common tungsten bulb and a fire. Both are good examples of how warm light can create a very intimate feel.

JOEL: Mirrors are never used enough in photographs. A mirror is a great way to show both sides of the room at once. It's an easy, easy way to make an interesting picture out of a common scene. In this case, there is just one lightbulb in the bathroom and this is probably shot with a 35mm 1.4 lens on film. It's a good lens for shooting in low light.

JOEL: (below) There's a time in every day when the level of light thrown by a fire equals the ambient light in the sky. One nice way of shooting people next to a fire is to not include the fire in the photo but show the glow on their faces. The worst thing you can do in a situation like that is to turn your flash on. Flash ruins a lot of pictures. It pulls all the natural warmth and all the natural graceful light out of your photograph. I've never yet seen a flashed photograph that beats mother nature's subtle, ambient, natural light.

Better Vacation Photos

There's nothing like the freedom of a vacation and a new, unexplored place to inspire you to take photos. You may even be using a new camera, bought specially for the trip. So don't take the same, tired pictures. Break old habits. Instead of gathering everyone around for a posed shot, have your camera ever ready. Keep it on and set to the conditions you're in. Now, be a journalist: document what happens. Tell your family to ignore you; then, watch for good moments. Take several frames of each scene. Try different compositions with the same shots. It's amazing how a similar photo can have a completely different feel with a small adjustment of angle or slightly different timing.

Keep an eye out for good light, or plan an outing when you know the light will be good—early morning and late afternoon are prime times. Think about vantage points: Can you get low or high? Also, try to occasionally keep some space between you and your family so you can take in the big picture. Those shots can be great, too.

If you have a fun idea for a photo, make it happen. In this particular shot, the overall scene of the family on the dock is okay, but you don't get a real sense of how large the fish is that Cole caught. It was as large as Ellen. By laying the fish next to Ellen, Joel accomplished two very important goals in photography: a clean background, and a composition that ac-

complishes the task of telling the viewer that the fish they caught was huge.

JOEL: *You really have to know your family members and know what they'll tolerate, and see if they'll agree to it. You'll need these people for years to come for your pictures, and you can't burn any bridges with them. You're gonna need them to take care of you when you're old . . . so it's important to make them feel like they are part of the shoot, to let them have some input into how it goes, and to make it clear to them that there is a payoff. I pay my kids in ice cream all the time if they have to lay next to a fish or pretend to kiss a frog, or stand there when it's really cold out while I get the exposure right. I always make it worth their while.*

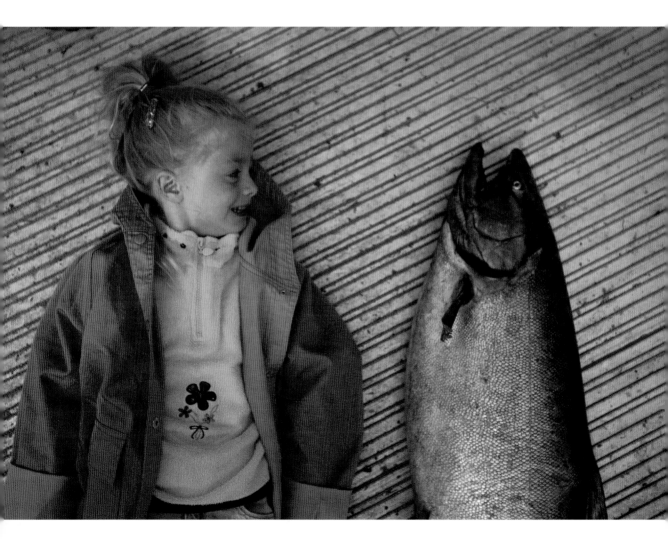

Friends on the Range

Photography often comes down to good timing. It's important not to get caught up in the technical stuff. If you have a beautiful scene and nice light, it's hard to go wrong.

This picture uses the rule of thirds from Chapter One and a good depth of field to capture as much background detail as possible. (To achieve this, select f/8 or higher. This was shot at f/8 @ 1/60 of a second at 50 ISO.) The second photo is similar in nature, but a very shallow depth of field captured the intimacy of the scene (f/2.8 at 1/100 of a second and ISO 100). Both are real moments that happened be-

fore a more formal, prearranged portrait. Many times, the unexpected photos are the most poignant.

One technical reminder: If a scene is darker or brighter than your camera expects, it may not turn out well. Simply adjust the settings manually to increase (brighten) or decrease (darken) the exposure. Or use the exposure-compensation function if your camera has one, then set it back to normal when you're done. If you are still nervous about using ex-

posure compensation, bracket your exposures manually to be sure you get what you want.

JOEL: I like pictures that are centered, where the family is right in the middle and everything is symmetrical, but I also don't mind getting the people off to the side of the frame. Remember, the first rule is there are no rules.

Museum Trips

Color is one of the most influential ways a photo communicates emotion. Always be on the lookout for color when taking photos and think about them just as you do the background, foreground, and your subject. It certainly helps this photo that the blue fountain contrasts with the boy's yellow shirt. Everything from similar colors, contrasting colors, and even lack of color can be used effectively to make a good photo. This picture is simple from a settings standpoint: normal depth of field (f/8) and plenty of outdoor light (ISO 100) and a shutter speed of 1/125 of a second.

JOEL: I'm not a fan of this photo because it represents a failed attempt to document this place. I don't see it as a successful thing because the light was very flat and back-lit. At least it was accurate for how my son was at the time because he wanted to stick his hands into everything. But as a photograph, it's not that successful. The main thing is that I went there hoping to photograph this art gallery. Some of the artists objected to having their art photographed, so I shot the outside of the building, which is public domain (and I don't need permission to shoot public domain areas). As I wondered what I could shoot, Spencer crawled into the artificially blue fountain. He laid down and kicked things around. I thought about the background—this [fountain] going off—and I tried to keep the background straight. I kept the background in focus, and then I tried different angles—right, left, in the center—positioning the subject. You can't teach the angles, you have to learn that on your own.

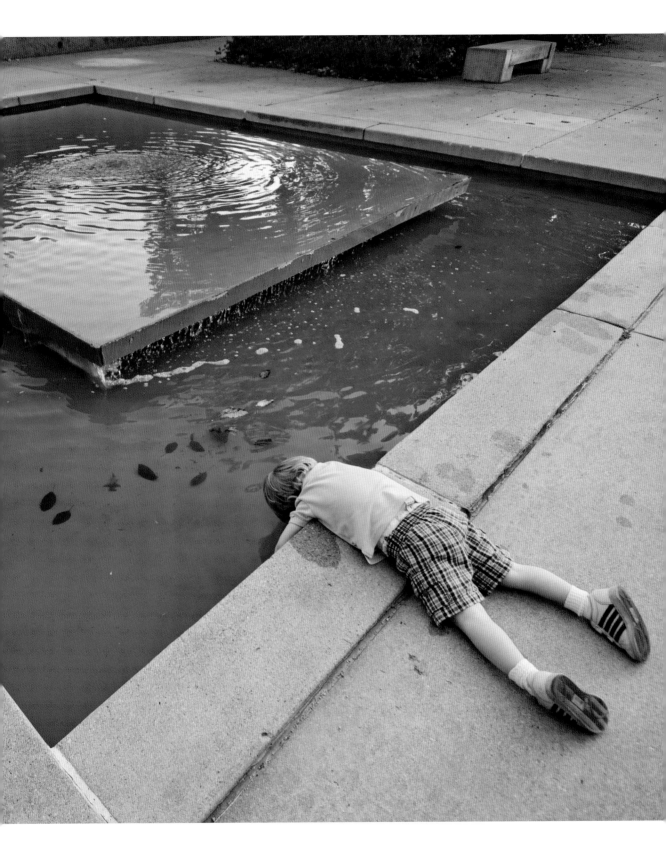

Sleeping Photos

During the rare times your child is motionless and not throwing things, screaming, running, or otherwise in standard kid mode, experiment and take more time on pictures that generally get overlooked. Sleeping, eating, bathing—now's the time to capture them before they become all grown up and prickly about being photographed.

As with all your photos, start from the background and work your way forward. Find an angle with a clean, unobstructed background. Simplicity always makes a strong statement. Think about how you usually see your child and how you can change your perspective. There are two different vantage points here that convey two different stories. The

overhead shot allowed Joel to focus on the Scooby Doo character as part of Cole's sleeping habits at the time. The lower, close-in shot of Ellen conveys a sense of intimacy and gentleness.

Watch for good light—or make your own by opening or closing shades or turning lights on and off. Avoid using a flash for the obvious reason of not waking your child, but also because it will create ugly, harsh lighting.

You may be wondering how you get an overhead angle without actually looking through your viewfinder from overhead. There are two ways. First, you can hold your camera above the child, press the shutter button halfway to focus and expose, then click the shutter. After a few tries, you'll get a fairly

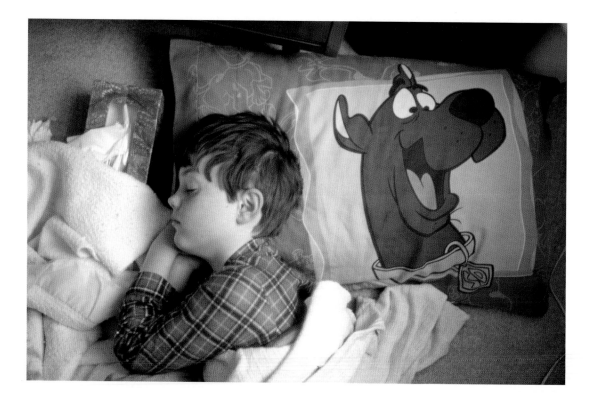

good frame. Another way is to estimate the distance from which you'll take the overhead photo and then prefocus from a similar distance on the side. Then, without looking through the viewfinder, position the camera over the child and snap a few frames. If your camera has a viewfinder that swivels or rotates, you may be able to use it to compose the picture. You can also use your camera's self-timer if it's difficult to press the shutter button while holding the camera. Keep in mind that it will usually be dark, so use an ISO of at least 400-800 and a wide aperture to make sure you can keep your shutter speed at a level that won't blur from camera shake.

Finally, be aware of juxtaposition just as you would color, shape, and form. Even though it's not a mode on your camera, wittiness makes for great photographs.

JOEL: *Sleeping people are really fun to do. They can't get away from you. You can use a tripod, a slow shutter speed (since they aren't moving), and get a lot of depth of field. And there's no reason you shouldn't because you have access to them.*

That's a single lightbulb lighting Ellen. It's late at night and she fell asleep on the couch. She had been dressed in all sorts of goofy outfits. She's like Imelda Marcos or something; she's got a 100 pairs of shoes and 50 dresses and it's constantly surprising. She's trying to figure out what fashions make sense. She often falls asleep in those outfits and there's my chance. No ice cream required!

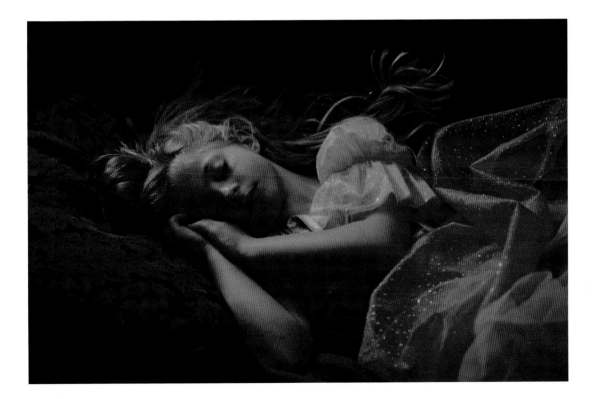

Texas

JOEL: This photograph was shot on a National Geographic assignment in Texas at a wildlife refuge. I was supposed to be making an interesting picture of the land. It's a very flat, dull landscape and it had been grazed over pretty heavily. These cows were all around the car. Again, it's just using mirrors. I shoot sideview mirror pictures a lot. It allows you to shoot in front of you and behind you at the same time.

Portraits

You may notice something similar about the portraits on this page. Each was taken in good light against a very simple background.

But what is good light and how do you find it? Some people are better at seeing it than others, but it can be learned.

Light has many different colors, from very cool and blue to very warm and yellow. Sunrises and sunsets are usually quite warm, while midafternoon light can seem much cooler and white. Overcast days tend to be far bluer than sunny days.

Light can also be hard or soft, and you can tell which by looking at shadows. If a shadow is defined, the light is direct. Soft light and its shadows are more diffuse—maybe it's coming through a canopy of trees or a sheer window curtain—and more flattering for faces.

Finally, the direction of the light is important. Hard light from directly above or directly below looks ugly. Think of the single, overhead bulb of a police interrogation scene in a movie. On the other hand, side light—think Rembrandt's paintings—can create a pleasing triangle of light under the shadow side of the person's eye.

Try to notice the way light comes into your home at different times of the day. What does it look like in the morning, afternoon, and evening? Where could you make a lovely portrait?

The "classic" portrait lens is 80mm. It offers a compromise between the wide, distorted look a 35mm can give, while being long enough to easily blur the backgrounds when using a smaller aperture value (longer focal length lenses have less depth of field at a given aperture than a wider lens).

JOEL: People will do much more interesting stuff if you let them do their thing rather than directing them. Sometimes when I am up on a ladder, I'll just pretend to be looking at my camera, or fixing it, and I'll take a few frames because those are the interesting pictures.

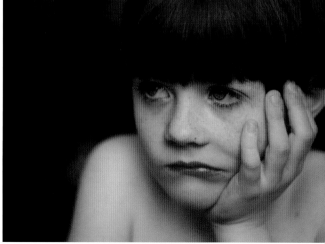

Formal Portrait

As mentioned on the page about family portraiture, you need three basic items to make a decent portrait: a tripod or a good facsimile, good light, and a "stage," or decent background.

Lenses matter as well. Most people have 35mm lenses, and these work fine. But if you have only a 50mm lens, all is not lost. Just be sure not to get too close to your subject with a wide-angle lens. This lens can create unpleasant distortion in the face and body, not unlike what you might see when looking at the world through the bottom of a glass. If you must use a zoom lens, set it to somewhere around 80mm and try shooting with an aperture between f/4 and f/8. You'll find the subject appears separate from the background in the photos. If you shoot your subject far from any background, you can choose higher apertures of f/11 and still be able to blur out anything behind her. But be careful about the light. This won't work in soft lighting.

Composition is the final but no less important consideration. People generally look more flattering when photographed from slightly above their eye level (and often weird when photographed from below). Try a variety of compositions, from full body to very tight. Also try some with your subject looking directly into the camera and then looking away from it. Be on the lookout for those natural moments between poses. Those can be among the best photos.

JOEL: *I like photography because I don't have that great a memory and I don't keep a journal. But if I shoot a picture, I'm really guaranteed to remember that time. I guess that's because of the visual. My biggest motivator in photographing my family in a documentary style is keeping it from being boring. You make far more interesting, better pictures if they are personal and revealing and away from the grip-and-grin mentality. Your family keeps your pictures interesting. Photography gives you a great documentation of your life as you go through it. When you take a picture of your wife, son, or daughter, free of disease and unhappiness, they are always going to be that age in the photo. It's the perfect way of stopping time, and we are so lucky to have this great gift. Before photography, only the wealthy could afford personal, painted portraits. So all you see are leaders such as George Washington, Thomas Jefferson, and Ben Franklin over and over again. Think of all the generations before us who didn't have pictures available to them. After their relatives passed on, they were not able to remember what they looked like after many years. With photography, which is relatively inexpensive and widely available, you can stop time, remain young and happy-looking. Why not take the time to choose the expected and unexpected moments?*

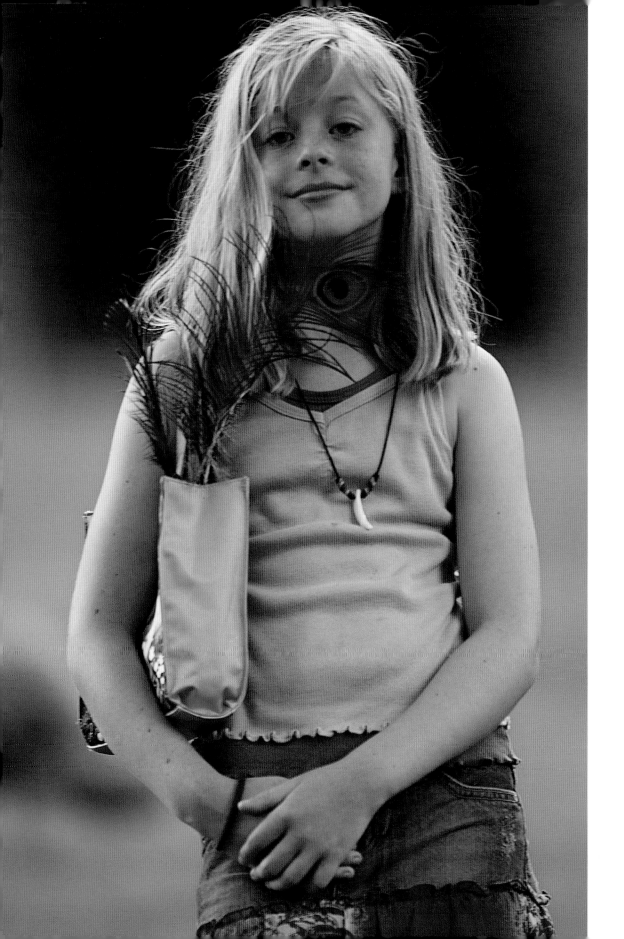

Creating a Story

Telling a story with photos can be an interesting challenge, and it can also help you come up with ideas for photos. The classic *Life* magazine formula for a photo story includes: a wide, scene-setting photo, tight detail shots, portraits, and the "meat" of the story—pictures of what was happening. Together, these photos convey a sense of time and place.

Whether you are on vacation or just going to the store, sometimes it's a good idea to create a story line in your photography to help you make interesting pictures. Kids have a story line in their heads most of the time; they pretend to be princesses or kings, pirates or butterflies. By analyzing the story you want to tell ahead of time, you may put yourself in a position where you might not have had a camera otherwise.

If you are having trouble coming up with a concept, pick up any magazine story and look at how the pictures flow from scene-setter to action to portraiture. Then apply those same techniques to the next backyard game of tag.

JOEL: Our friend has an Easter egg hunt every year. One year Kathy made the bunny outfit. The next year she made the carrot so that the bunny would have something to stand next to in pictures. Later, I also took the bunny to the grocery store and to the dentist.

Street Photography

Among photography's great pictures, street photographs are also some of the most memorable: Robert Frank's photograph of a woman looking out the open window of a New Orleans trolley car, Garry Winogrand's image of a beggar pan-handling on Rodeo Drive next to two smartly-dressed-yet-oblivious shoppers, P. L. DiCorcia's mesmerizing images of people isolated and seemingly lost in a sea of humanity on a New York City street.

The key to capturing these scenes is patience. Choose the camera settings you need for the light available and wait for moments to happen. Or think ahead about what might happen and be ready for it, camera focused.

Here, Joel has captured the composition nuances of great street photography, but he also threw a curve. Instead of waiting for Ellen to bounce the ball so high that it obscured her face, he simply asked her to bite one of the ball's spikes so it would stay put in front of her face.

JOEL: *This is Ellen standing with a green ball out in front of my mother's old house. It's just something goofy to shoot for fun. Sometimes the pictures don't make any sense at all; I just want to have fun. They don't have to please anybody but me, and most of the time they don't.*

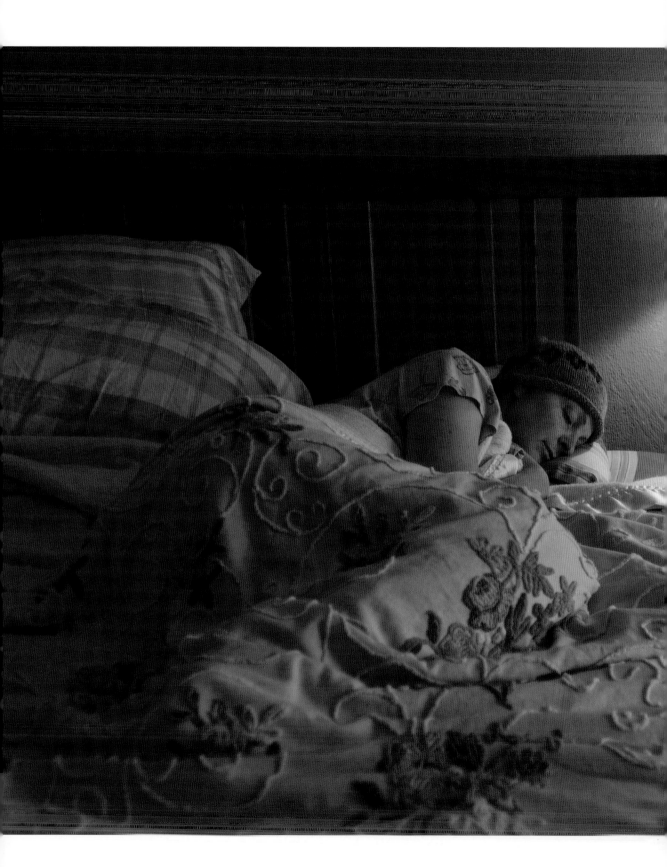

Cancer

JOEL: *When Kathy was sick, I barely shot. We agreed that we should have a picture or two because it was the biggest thing that had happened to us in the twenty or so years we had been married. We didn't know how sick she was gonna be, or how it would go. Because I had documented everything else, that would have been a giant hole if we didn't shoot something. I literally think I only shot three things: her sitting on my mom's couch with no hair, her in bed, and her visiting with her doctor. Now she's fine, so we have returned to a normal life, and we have a much better appreciation of life, hopefully, and how blessed we are.*

A Day with Grandfather

These photos offer good examples of simple techniques making better pictures. Both the photo of Cole with the frog and the close-up of Cole and his grandfather use a wide-open aperture (around f/4) and proximity to the subject. This selective focus helps the photos—emphasis remains squarely on the frog and the fishermen. With a larger aperture value of perhaps f/22, everything would be in focus, and the pictures wouldn't feel as intimate.

The long shot of the two fishermen employs the rule of thirds, negative space, and framing. Having the boat off center creates visual interest, and the grass at lower right provides balance for the boat. Finally, using a relatively wide lens makes for lots of negative or empty space that doesn't compete for attention.

JOEL: The fish weren't biting and I was looking for something to do. So I had them drop me off. That pond hasn't been great for fishing in the last few years. There's a lot of frogs and that always gives us something to do. It's a nice big flat body of water and the light is usually nice. You might as well shoot a few just to remember a situation you liked. Even better is not shooting anything and just enjoying the evening. If it looks idyllic, then shoot it, but don't make a big production of it.

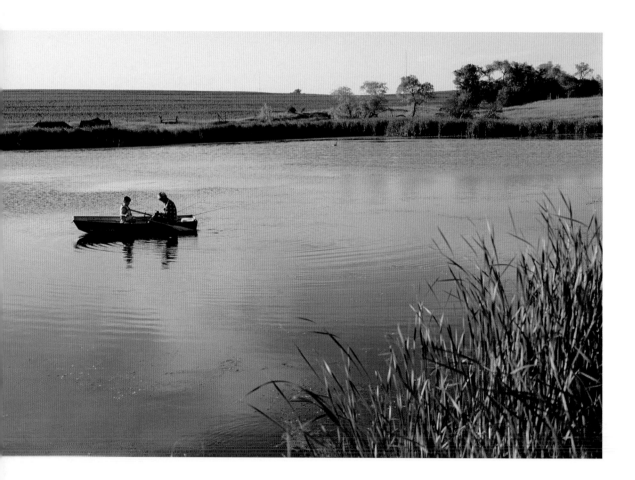

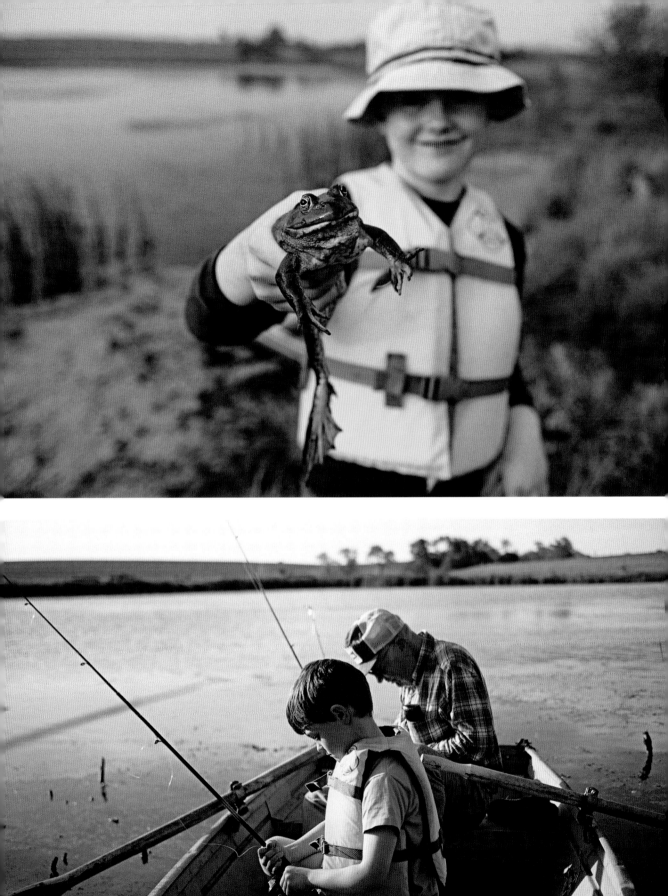

Selective Focus

An interesting vantage point—in this case, crouching on the ground next to the mushroom—and a wide-open aperture make this picture really different. Joel also chose to include the environment as an important detail rather than focusing on Ellen or the mushroom, or both. The soft, late-afternoon light is also a big plus, far better than the harsh light of an overhead, noonday sun.

JOEL: *Every spring we go mushroom hunting around our house and I photograph Ellen with the mushrooms. I wanted to show her intensity. She's really into it. It's one of the most anticipated events each year. I once flew back early from Tokyo just to make sure I didn't miss the weeklong season.*

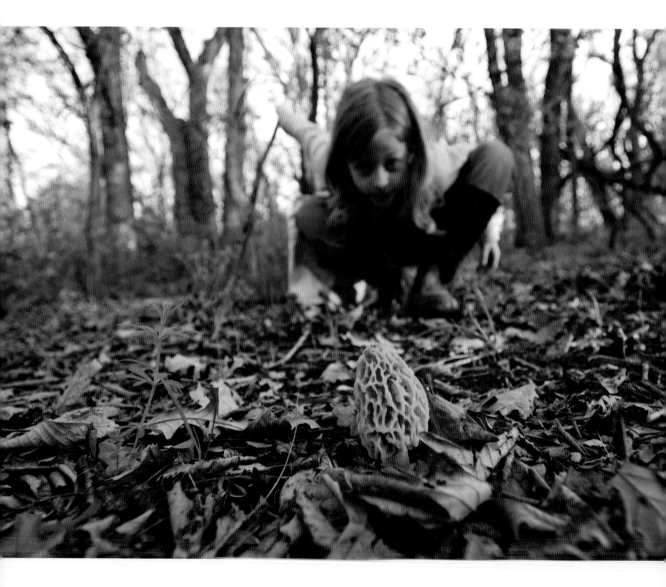

Underwater

Whether it's bathwater, pool water, or ocean waves, water can help make a picture memorable. The aspects of photography that change when you are underwater are: the ability to focus well, the amount of light, and in some instances, the depth of field.

You don't need an expensive waterproof camera, either. Waterproof camera bags—called housings—are relatively inexpensive and can hold anything from a point-and-shoot camera to a bigger SLR camera. Buy the one that fits your needs.

While you are learning, shoot when there is plenty of light so you can set a higher ISO than you might outside in the sun (400 would be a good start) and an aperture value of f/11 or f/16. The increased depth of field will help fix any focus issues the water should cause.

JOEL: I wanted to play with bubbles underwater. I took Cole to a local YMCA pool to test an underwater camera housing for the first time and I learned that underwater shooting is slightly more complicated but really worth it.

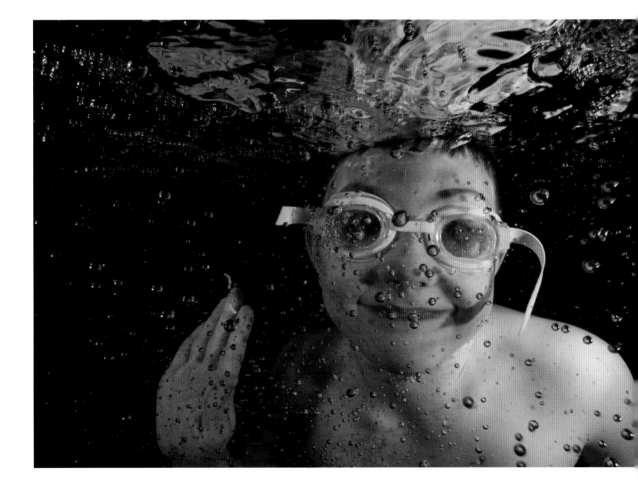

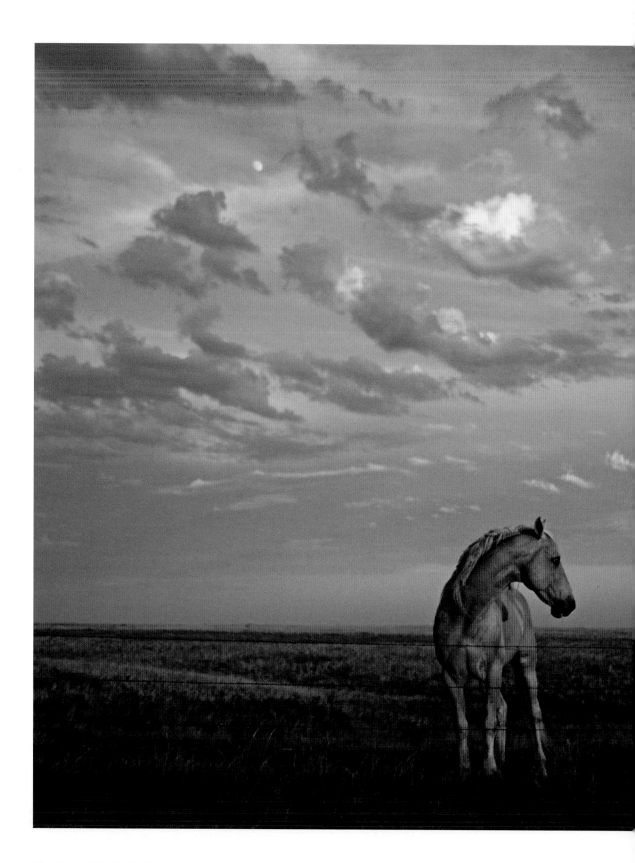

Afternoon Light

When taking photos of sunsets, it's easy to get the exposure wrong and have the sky come out way too bright. To avoid this, point your camera up at the sky and see what settings it shows. If your camera has an exposure lock function, lock the exposure settings when your camera is pointed at the sky. If you're using an automatic mode, note what settings it calls for when you point the camera to the sky. Maybe it's showing you 1/80 of a second at f/8, but when you recompose the shot at the ground it gives a longer exposure of 1/20 at f/8. If so, switch the camera to manual, set it to the sky reading of 1/80 at f/8 and take the photo. With the camera set to the brightness of the sky, you'll get good detail in the clouds, the light in the sky, and nice effect on the ground, too. Sometimes you'll have to split the difference and choose a setting somewhere in between.

This photo effectively breaks the rule of thirds in the horizontal frame (side to side), but notice how it uses the same concept in a vertical manner? When the frame is divided into thirds, the horse is roughly in the bottom third and the sky in the rest of the frame. The photo has both balance and a great sense of place.

Capturing the horse with his head turned away from the camera also adds interest to the picture by making it seem the photographer wasn't there at all.

JOEL: *This was one of the nicest, quietest scenes I had seen in a long time. Environment can mean a lot of things to a lot of people. You don't have to have items of real physical significance in there. It could be just a lack of congestion and traffic and noise.*

Bad Weather and . . .

Rain, like water, can be a powerful element in photographs. And when the weather doesn't cooperate, a sprinkler can do just as well.

What makes this photograph special—beside the incredibly forlorn dog and the happy children—is the simplicity of the background. The drops of water from the sprinkler stand out against the dark background. To freeze the drops of water in midflight, you must use a slow shutter speed—about 1/60 of a second—but be careful to stabilize your camera while you are using the slow shutter speed because any movement in the kids or by the dog ruins the photograph. About 1/60 of a second is as slow as most people can set their camera without suffering camera-shake blur, but with

care you may be able to slow to 1/30 or 1/15 of a second. If you don't have a tripod, you can use any flat surface or bag of frozen vegetables around the camera to help you stabilize it. And don't forget to try a few of the aperture settings until you find one you like.

JOEL: I like bad weather. Sam Abell, another National Geographic photographer, once said that when the weather turns bad is when people put their cameras away, so that's when he goes out to shoot. The light is really unusual and dramatic when the weather is bad. Sometimes you'll have direct sunshine and a black sky in the background. It's really interesting light, beautiful and soft.

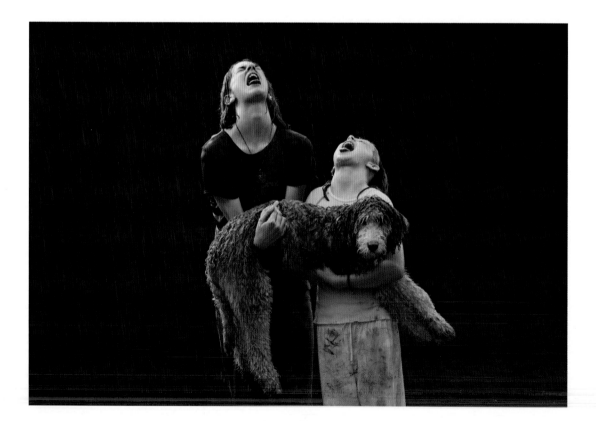

The Blues

There's a little trick at work in this photo that you can try with a digital camera. When you set your camera's auto white balance to its tungsten setting, the camera renders the indoor tungsten lights correctly. But notice how blue it turns the outdoor light hitting the house. This contrast turns an otherwise mundane photo into something more.

You may not realize it, but your eyes are constantly auto white balancing themselves. When you drive past homes at dusk and see yellow light coming from the windows, your eyes are white balancing for the evening sky, which is often very blue. When you're inside, surrounded by that yellow, tungsten light, everything outside appears blue to you.

Cameras are quite sensitive to these color changes. By changing your white balance to a different setting than auto white balance, the colors of your photos will look very different. Again, these are simply more tools to help you make your photos better.

The next time you are outside at twilight, try to "see" the different colors in the lights as your camera does. You will become more aware next time you shoot.

JOEL: My parents spend an inordinate amount of time washing dishes. The ambient light on the outside of the house was very blue and it matched the intensity of the light in the house. There are only two times during the day when you can do this—at dawn and at dusk.

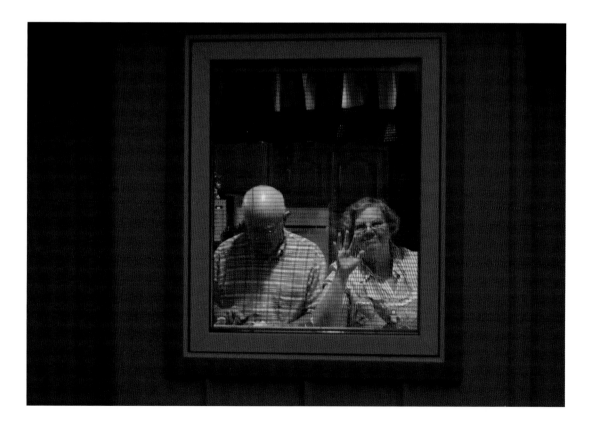

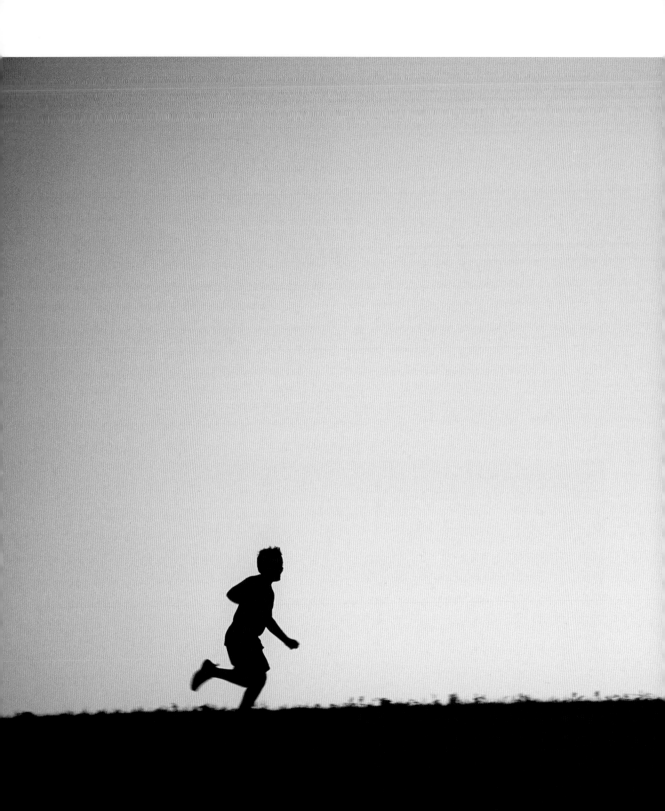

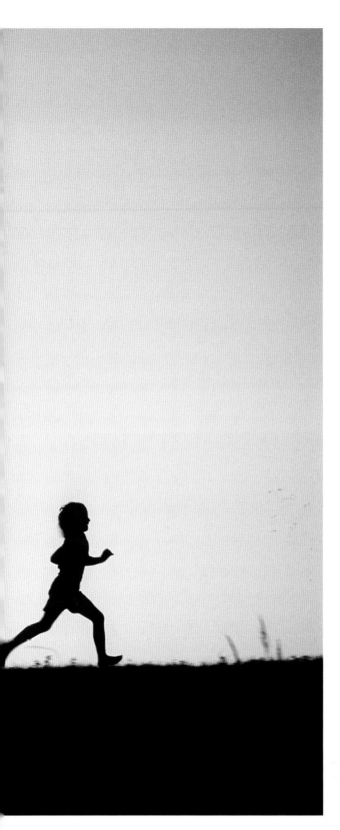

Silhouette

JOEL: This was shot at Holmes Lake dam in Lincoln. It's one of the only open spaces here where you can get a skyline. It's a big, elevated dam with no trees, and it's maintained by the city, so they keep it open, clean, and mowed. A lot of people use the top as part of a walking or jogging path. We went out there to run the dog, and I had my camera along and thought it would be fun to get a picture of the kids walking the dog. Instead, they just went out there and started chasing each other. I didn't have the heart to tell them I really just wanted a silhouette picture of them walking the dog, so I just shot them doing what they were doing. Even when you try, you really have zero control over kids. And sometimes that can be better—it can be a real advantage.

Inside Play

Trying to capture the moments of childhood means first recognizing them and then photographing them. Think about what each of your children likes to do. Ride tricycles around the dinner table? Create little sets around the house with bits of cloth and tiny dolls? Does your daughter obsess over puzzles or your son wear his Superman outfit everywhere? Remember, these phases don't last forever, so try to capture them in photos. Joel tends to keep cameras within easy reaching distance (albeit out of the reach of little fingers) all over the house. This way he can anticipate the scene (by watching his kids), seize the opportunity (by having his camera handy), and set the camera before he has the chance to shoot.

JOEL: This is an example of trying to make a picture where there's good light—in other words, looking for a stage and waiting for a player to appear. In this case, that was a spot where Cole was hiding and sticking his head out one afternoon. I always have a camera nearby and recognized that the light was both bright enough and soft enough. If you know your house and you know what looks good at certain times of the day, when something fun happens you won't be caught off-guard. That's a place he played all the time. That picture wouldn't work first thing in the morning—too dark.

If I can, I get down on the subject's level. It's more intimate and less boring than shooting from your own eye level. Get down lower or get up higher if the situation calls for it. It's all about different angles.

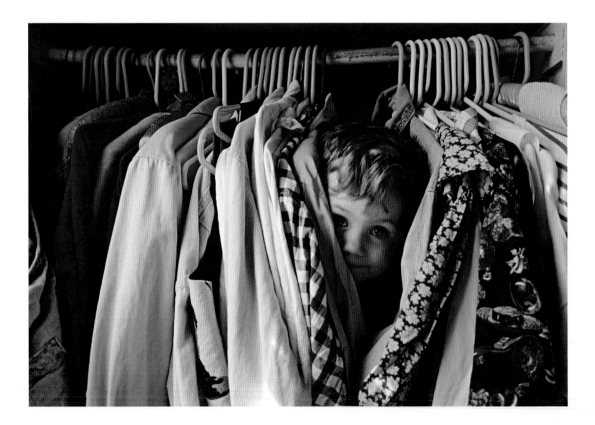

Outside Play

Try not to rush it when making a portrait. Move around for different compositions, keeping an eye on the background to avoid weird stuff happening (like a chimney sprouting out of a head). Remember that both subject and background are crucial for a good portrait. A little something in the foreground doesn't hurt either, such as other people, bushes, or even cars and mailboxes. Anything you add or subtract from the picture can have a big impact.

In this case, Joel used a small aperture value of about f/5.6 to blur the homes behind the boys. This keeps your eye focused on them, while still giving you a sense of where they are. The wider depth of field also allows the boy playing in the background to add some interest to the picture. Without other people in the frame it could feel like a ghost town. Notice his vantage point, too. It's low, just about eye level with the boys. This gives the photo a very different feel from one taken at an "adult" height.

JOEL: For a project about Lincoln, Nebraska, I was in a historic district at sundown. I shot a few frames of the boys chasing each other around, and then they held still for a portrait. I made sure to ask permission first at one of the homes where the boys' parents lived. Many people are paranoid about strangers these days, so you have to stop and ask first.

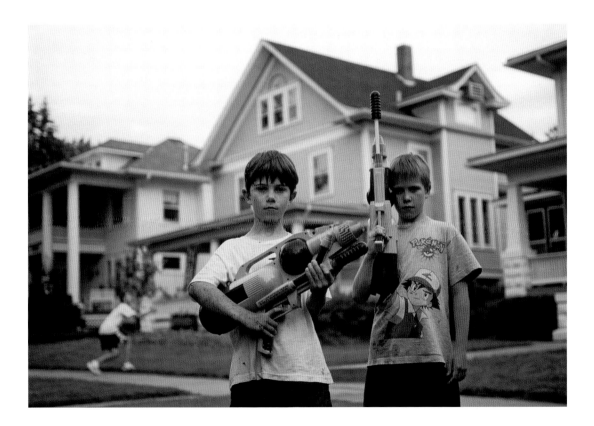

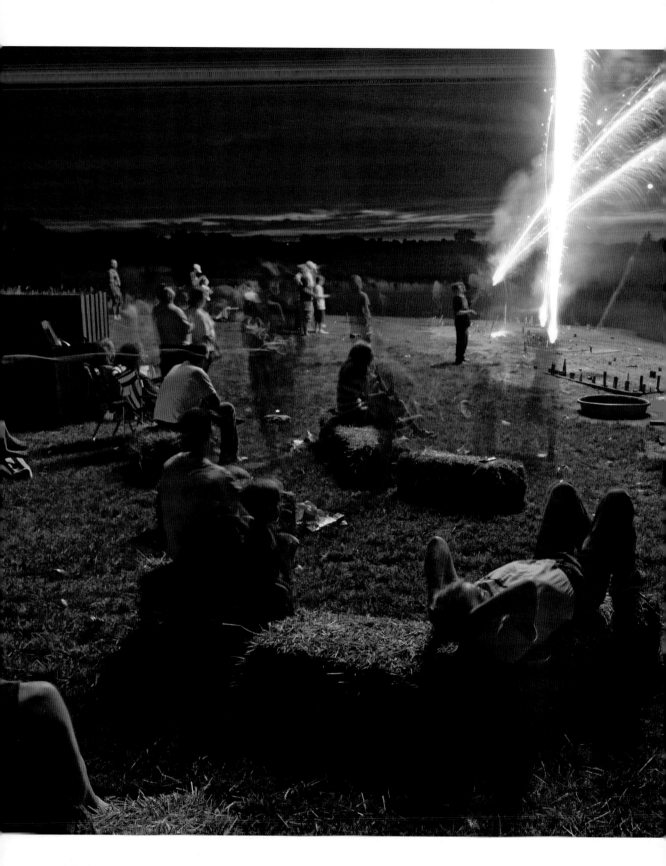

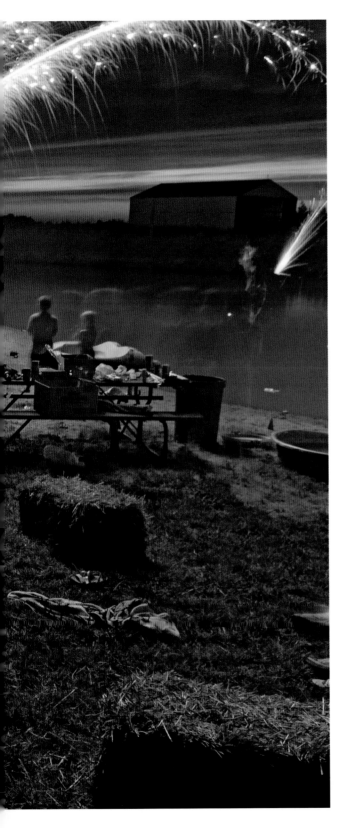

Fourth of July

Nighttime photography presents challenges. Dim light requires a higher ISO, slower shutter speed, and/or a small aperture number. A built-in flash might help, but only for a range of about 15 feet. Set your camera's ISO to at least 400, and follow these tips for successful nighttime photos.

1. Set your camera to "landscape" mode, in which many cameras choose night settings and no flash.

2. Some cameras have a "nighttime" setting that will either turn off the flash or use it in combination with proper nighttime settings.

3. Turn off the flash yourself and set the camera to "P" or one of the other semiauto settings.

4. Use a tripod. Your camera will be steady (though your subjects may not be and will blur easily).

Photographing fireworks is difficult but not impossible. First, stabilize your camera, most easily with a tripod. Next, prefocus the camera on the area where the fireworks will be, using a larger aperture number for more flexibility with focus. If there's nothing to focus on in the fireworks spot yet, focus on something about the same distance away.

Now, set your camera to manual mode and control the exposure (you'll need long ones) yourself. Begin at ISO 100 and set your camera to f/11 at 1/2 second. With the slow shutter speed, even pressing the shutter button will cause camera shake unless you're very careful. To prevent this, use either the self-timer or a special release cord that attaches to your camera and allows you to activate the shutter without touching it.

If your pictures are too dim, increase the shutter-speed duration but don't change the aperture, and set the white balance for sunny or shady conditions.

Ellen's Room

Your perspective when photographing kids is a valuable tool. Most of the time your height allows you to look down toward them. In this case, it makes sense to photograph Ellen from the vantage point of an adult because this is what Kathy and Joel look at every day when they open the door to Ellen's room. The lighting is natural, so start with an ISO 200, a shutter speed of 1/60 of a second, and an aperture of f/4 to duplicate the picture here.

But wouldn't it be nice to see the world from their perspective for a change? Get down on your knees, or your belly. What does the world look like now? Try photographing someone from these heights. How large does the dog really look from a three-foot perspective? Is attending a family party like standing in a forest of knees for your two-year-old? Does the backyard look as large as a football field?

Try a wide-angle lens to take in even more of the scene. It's a big world out there to them, and you'll be able to capture their view (which is fleeting in itself since their height changes seemingly every week).

JOEL: Her room looks exactly like that right now—like somebody ransacked it. That's not something you have to work at around my house. Even when we have company, she just closes the door. It's so bad now she uses her bed as a storage area and sleeps on the floor in the middle of the pile.

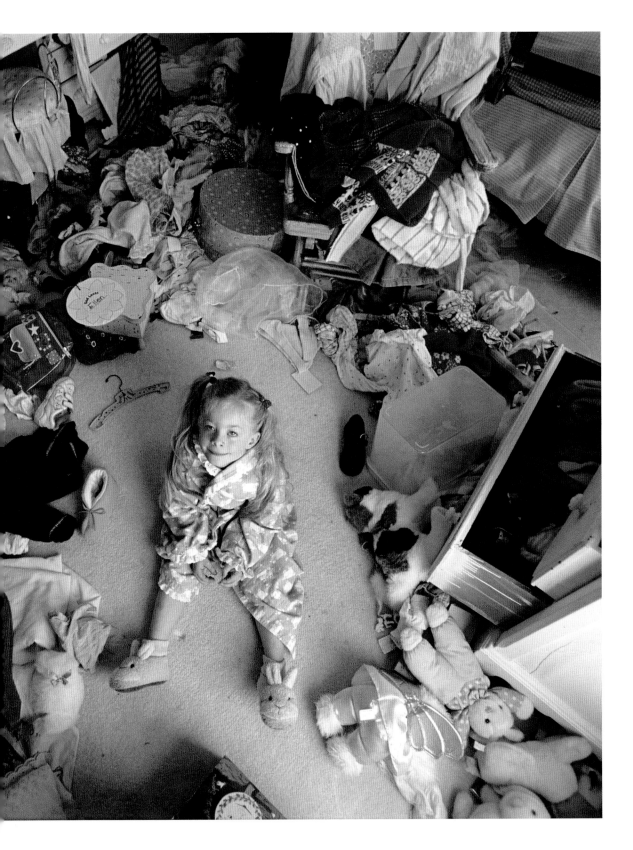

Ear Piercing

None of these photos is made using a flash, but if your camera has the option of a "fill" flash setting, you could get away with using flash. It sounds technical, but it's pretty simple. Essentially, you are asking the camera to expose the scene as it would without flash, then add a bit of flash to differentiate the subject from its surroundings and freeze the action a bit.

It's possible to do this manually, but the fill-flash option on your camera makes it easy. Remember that your flash will only reach about 15 feet, so it won't work with a subject farther away.

We've said all along to avoid flash, but there may be times when you're more interested in getting a well-exposed photograph than in creating art. A birthday party or a big group of people in varying amounts of light would be a good example of where to use fill flash. And while this may be a time to use the full-auto function of your camera, using the fill-flash setting with some of your knowledge from this book can make the picture look much better.

Try using the fill flash first on your camera's full-auto mode to see what effect it gives you. Then set your camera on a creative mode, such as shutter-speed priority. If you're indoors, make sure your ISO is set to about 400, then select a shutter speed of 1/60 of a second. Try a picture. Often the subject will be correctly exposed, but the background may be pretty dark. Keep slowing your shutter speed until the background becomes brighter: Your camera should automatically keep the flash brightness the same.

An interesting thing about flash is that it freezes whatever it lights up, assuming that it is brighter than the ambient light around it. So if you're using a slow shutter speed of 1/30 of a second or longer, using a fill flash can help freeze your subjects. Pros will use really slow shutter speeds of 1/4 of a second and mix this with fill flash to achieve very interesting effects.

As you are taking photographs, try to think about what's essential to the picture and what's not. For example, the employee who's doing the piercing is probably not all that important to you. Don't try to get too much in one picture or you risk losing your central focus.

JOEL: This was a big deal. My wife agreed my daughter could get her ears pierced when she was ten. I had never seen the needle hit the skin. I thought it would have been interesting to see how a child reacts. When a major event happens in the family, you want to make sure you're there for it.

Ellen's used to me taking pictures. She just chose to ignore me, which is great—just what I want.

Cookies

Notice how Cole's hat is at the top of the frame and the cookies at the bottom? Break the habit of keeping a distance from your subject. Use a wide lens (this is about a 35mm), and get up close. Because the picture is inside and in low light, use a high ISO of about 400, and a small aperture number. This also helps the background slip out of focus, leaving the budding chef to enjoy the photo's center stage.

JOEL: *Being ready is key. Keep your camera set on autoexposure and autofocus so you are ready to go indoors.*

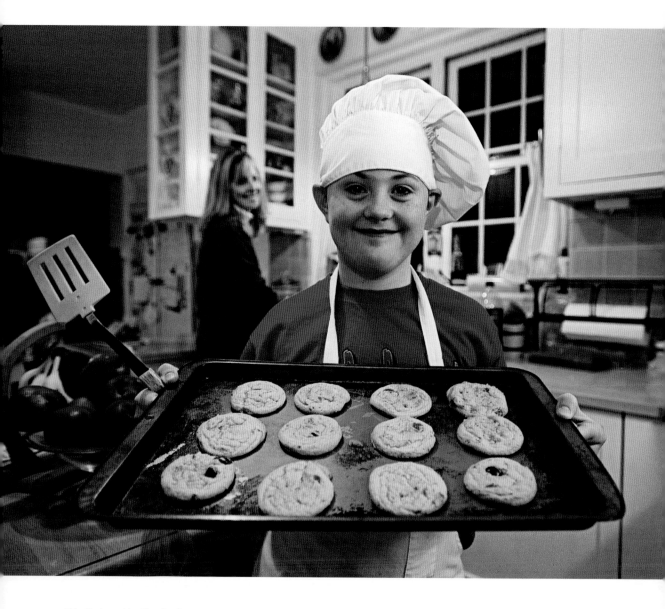

Rembrandt Light

When the intensity of light alternates within a picture, a camera's automatic mode may misinterpret the scene and not expose it correctly. There's a lot of darkness in this scene, which could result in a too-bright photo with the camera set on automatic. To avoid this, point your camera at a bright area in the photograph, such as at the window to the left or the light on the baby's face. Notice the difference between that exposure and when you point your camera at the overall scene.

You have two options. The first is to point your camera at the bright part of the scene and press the shutter button down halfway. Most cameras will set the exposure and focus. Now, recompose (while still holding down the shutter button halfway) and then take the picture. The problem with this method is that your focal point might not be as equidistant as the bright spot in the picture. The other method is to look at what settings your camera sets when you point it at the bright part and set those same settings using your camera's manual mode. Now you can focus on your subject correctly.

JOEL: *The whole point of a good photograph is to show what is going on in your life at the time—what matters to you.*

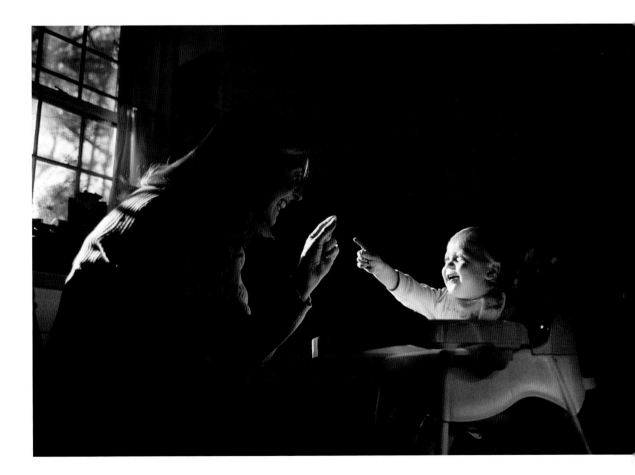

Muldoon Smiles

JOEL: *For the smiling dog, I used fishing line. It's a fine mono-filament line you can't see. I'd lift the line with my left hand, snap the picture, and lower the line that's lifting his lips. The dog's happy, and I'm happy. She's a really smart dog and she was glad to do it, especially for a Milkbone.*

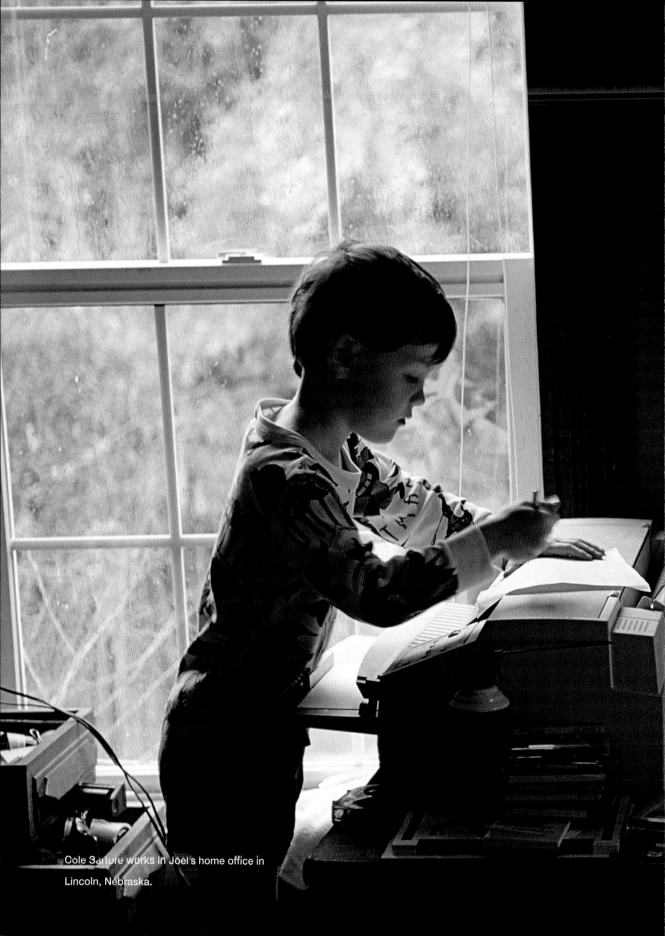

Cole Sartore works in Joel's home office in Lincoln, Nebraska.

Chapter Three
YOUR DIGITAL DARKROOM

Family portraits used to be very difficult exercises that included expensive studios and darkroom printing.

YOUR DIGITAL DARKROOM

The darkroom has always been where great photographs were made. While transforming a negative into a photographic print, the photographer could play with contrast, tone, and cropping—in other words, perfect the final image. The world's great photographs have all been nurtured in the darkroom to become what they are today: records of our history and, in some instances, works of art.

Thanks to computers and photo software, your pictures can look just as stunning without the chemicals, the special darkroom, or the stained clothes. All you need is the space on your hard drive and a few hours to learn some simple techniques. We will walk you through the basic steps here, utilizing one photograph so you can see the differences more clearly. Try the same at home with a favorite photograph. At the end of the chapter, you will find a handy chart of software on the market and from which to choose. On page 141 you will find a table of advice on hardware, whether you are a Mac person or PC person.

This window is what you would see on your computer if you opened up a RAW file from your digital camera in Adobe Camera Raw. Some camera vendors will include their own RAW conversion software with their products. If you look closely you will see that you can learn many details about a photograph including color temperature, shutter speed, aperture settings, and file size.

0, f/2.8, 17–55@17.0 mm)

dows ☐ Highlights R: --- G: --- B: ---

Settings: Camera Raw Defaults ⬍ - ⦿

Adjust Detail Lens Curve Calibrate

White Balance: As Shot ⬍

Temperature 5500

Tint +10

Exposure ☑ Auto +0.35

Shadows ☑ Auto 29

Brightness ☑ Auto 52

Contrast ☑ Auto +34

Saturation 0

(Save...) (Cancel)

(Open) (Done)

Ways to Edit an Image

Here we'll go over the simplest ways you can make your photographs look their best. Most photo applications will have many, if not all, of these controls.

To become acquainted with these tools, use a method of learning you've probably become intimately familiar with lately: play. First, make sure you've saved a copy of your image somewhere so you won't mistakenly save over it. Then, make a mess. Experiment. Throw the hue slider as far as you can. Pump up the saturation to ridiculous levels. Sharpen way too much. Raise the contrast to Andy Warhol levels. Then use the "undo" command to remove whatever mess you made. (One can only wish there were an "undo" command in the kitchen.)

This is a picture of Muldoon, the Sartore family dog, on the back porch. We will take this picture through a number of steps in an effort to teach you how the different, common controls in your image-editing software work. At the end of the chapter is a chart detailing software on the market so you can determine which one is best for you based upon cost and capability

Mode ▶

Adjustments ▶ | Levels... ⌘L
Auto Levels ⇧⌘L
Auto Contrast ⌥⇧⌘L
Auto Color ⇧⌘B
Curves... ⌘M
Color Balance... ⌘B
Brightness/Contrast...

Duplicate...
Apply Image...
Calculations...

Image Size... ⌥⌘I
Canvas Size... ⌥⌘C
Pixel Aspect Ratio ▶
Rotate Canvas ▶
Crop
Trim...
Reveal All

Hue/Saturation... ⌘U
Desaturate ⇧⌘U
Match Color...
Replace Color...
Selective Color...
Channel Mixer...
Gradient Map...
Photo Filter...
Shadow/Highlight...
Exposure...

Variables ▶
Apply Data Set...

Trap...

Invert ⌘I
Equalize
Threshold...
Posterize...

Variations...

Feather: 0 px Width: Height: @ 25% (RGB/8

Auto Adjustments

The "tonality" of an image—the relationship the shadows, midtones, and highlights have to one another—influence the clarity and emotional impact of a photograph. This is the most important adjustment you can make. A reasonably good, untouched image will often look outstanding after some simple, tonal changes have been made.

A general rule of thumb for a photograph that looks pleasing to the eye is that its shadow areas (blacks) are truly black, and its highlights (whites) are truly white. If neither of these is true, then the image will look "flat," or dull.

Most applications have an "auto adjusment" function. The software examines the highlights and shadows and adjusts the overall brightness on these values. On normal images with most of the image detail in the midtones, using the auto setting can work wonders. But it may cause weird color shifts or make the subject look too dark or light. If it doesn't work, select "undo."

Exposure

There are two different types of exposure. The first is the camera exposure setting you snapped the photograph with. The next is an exposure setting in the photo program. If you are working on a RAW image, the exposure setting mimics going back in time and changing the setting when you shot the photo—a great benefit of using the RAW mode. But if you are working with something like a JPEG file rather than a RAW image, the exposure setting changes the overall brightness of the image, and it's easy to lose a lot of crucial details and tones by doing so. Use this sparingly on non-RAW files.

Contrast & Brightness

ost of us know a fair amount about contrast and brightness because we adjust our TVs. Contrast controls the difference between the highlights and shadows. If increased here, it applies the adjustment to everything, making the highlights brighter and the shadows darker. Brightness will control how bright all the tones are, regardless of whether it's a dark-toned area or a highlight. Tone detail is lost quite easily using either slider, and detail is the essence of a nice photograph. So use these controls sparingly on an image that only needs minor tweaks.

For example, if the subject of your photo was dark and you wanted to lighten it, you could simply move the brightness slider to lighten the image. But now the clouds in the sky are gone and the shadows aren't as dark. Why? The brightness was increased not only for the subject, which was a midtone, but for the bright sky and the dark-shadow areas as well. Detail was subsequently lost in both.

Take these pictures of Muldoon, for example. By leaving the contrast alone and decreasing the brightness significantly, as below, the overall effect is a muddied, gray picture. The atmosphere is that of a dull, rainy day.

Then, if you slide the brightness point way over to the other side (top right), your picture becomes so bright that you start to lose detail in

the snow. See how the small clumps of snow behind him become washed out and pure white? You have lost the detail in the highlights.

The bottom two pictures help to emphasize the effect of contrast in your photograph. Too much contrast (left) and the colors become unreal. Too little contrast, and the picture becomes muddy again, but this time the surroundings look like you are peering through deep snowfall rather than the light on a dull, winter day.

Try a few of these exercises on more colorful images to see the difference between brightness and contrast in various colors. You may find a formula you like that could be your signature.

Levels

The level adjustment is a more accurate way to adjust the shadows, midtones, and highlights of an image as you control the quantity of change in each specific area. While the graph (the histogram you learned about in Chapter One) that usually accompanies this tool may look complex, it's rather simple.

The levels adjustment will usually have three sliders and a graph and will show the amount of darks, midtones, and highlights in your image. The graph tells whether your blacks are indeed black, and your whites (or highlights) are indeed white. You learned about this in Chapter One.

Usually, the left side of the chart will represent the dark tones, with the highlights or pure whites on the right. If your photo has pure blacks, the left side of the graph should begin at the very left side of the chart—if there is a gap between it and the left edge of the chart, then your image doesn't contain any pure black. The same applies to the highlights: The right side should end at the right side of the chart. If it doesn't, then there are no pure whites.

As you move the sliders, the graph will change. Moving the dark slider to make dark tones darker will bring the graph to the left edge. Move the highlight slider to increase the brightness of highlights, and you'll see the graph move toward the right. Then adjust the midtone slider so the image looks good to your eye. That's it.

COMPUTER REQUIREMENTS

If you are looking to buy a computer or wondering if yours is up to snuff for your photo software, here's a guide. All photo software has its system requirements on the box or online—be sure to read that before you purchase the software.

Processor speed

(how fast your computer "thinks")

PC

1GHz is recommended

500MHz is acceptable

300MHz at minimum

Macintosh

2GHz recommended

600 GHz acceptable

RAM

(your computer's short-term memory)

1GB recommended

512MB is acceptable

128MB minimum

Hard-drive disk space

(where your images and files are stored)

5+ GB recommended

1.5 GB acceptable

1 GB minimum

Monitor and video card

"Bit depth" or "bits" refers to the number of colors a computer display can show. The higher the number, the more colors are possible.

24-bit or higher color display and video card recommended

16-bit color monitor and video card acceptable

Operating system

(how your computer functions)

PC - Windows Vista or Windows XP (with Service Pack 2, or SP2)

Macintosh - OS X 10.4

Color Saturation

olor saturation is what it sounds like—how much color there is. Often, increasing the saturation a small amount will produce big results, but too much and the effect will look odd. Use it sparingly.

Check out Muldoon, below, with too much saturation. His shaggy, tan appearance looks positively orange. We got this result because the saturation drew out the undertones of golden color in his coat.

Color Hue

The "hue" of a color determines what shade that color is. You can have a greenish yellow, or you can have a reddish yellow. This tool is especially helpful in correcting skin tones, which have a big impact on how your photo looks. If skin looks too red, orange, or yellow, the photo will look odd. Experiment with adjusting either the overall hue of an image, or focus on the oranges, reds, or yellows to adjust skin tone to a natural-looking shade.

Color Balance

This is usually a more precise manner of controlling the combination of cyan/red, magenta/green, and yellow/blue in an image. Some applications allow for adjustments within specific tones (such as shadows, midtones, and highlights).

It's helpful to know some universal guidelines when you are beginning to color balance images. First, shadows are often bluish in appearance, whether they come from an overcast day or the shadow of a tall building on a sunny day. Correcting this would involve adding yellow (subtracting blue) and/or red (subtracting cyan) to the image. Next, some films and some digital cameras have a tendency to render certain parts, or even all, of your image with a color balance that is slightly off what would be considered correct. This is known as a "color cast." Some cameras may produce slightly green images, while others may look red. Finally, adjusting skin tones helps in making people look their best. Bluish- or yellowish-looking skin can be adjusted with color balance, as well as with the next steps of adjusting color saturation.

Tint

The amounts of green and magenta in an image are controlled by this adjustment, also known as hue. Experiment by adding or reducing tint in large amounts so you can see the effect either color can have in your photograph. Then reduce slowly to find a color combination that looks true to your eye.

Color Temperature

Color temperature changes an image's colors on a spectrum from blue to yellow. Although it may seem counterintuitive, images with a lower color temperature are more yellow overall and have a feeling of warmth that may or may not work well with your photograph. Images photographed with a higher color temperature are more blue and offer a completely different -- often colder -- feel. If the sunset you're seeing is warm but your camera renders it very blue, that's because it is color balancing the image to a cooler, bluer color temperature. If your camera has a white-balance setting, change it to the sunny setting to record the warm, orange cast of a sunset more accurately. Similarly, changing to its "shady" setting will keep a rainy, blue day looking just as it should. If you're unable or forgot to change the white balance of your camera, some image-editing applications have a built-in color temperature slider to do so. Still, the best quality will come from changing your camera's setting before you shoot.

White Point

White point is a setting that, depending on the application, either can be set by clicking on a white or neutral gray area of a photograph, or can be adjusted from a color wheel or palette. The goal is to make white or neutral-gray areas look perfectly white or gray. This should keep the other colors in the image looking correct as well. A white-point setting combines the color temperature and tint to correct the image.

Converting to Black and White, Toning

Changing a color photo to black-and-white can be an interesting learning process. Some photographs need color to be understood or compelling. Others, however, can gain a lot by being seen in only shades of gray, black, and white.

Toning a black-and-white photo adds a slight tint to the different shades of gray. Sepia is a popular term that is used loosely to describe toning a black-and-white photograph with a ruddy or brown color. It comes from a Greek word that means "cuttlefish." A pigment taken from this fish was added to early silver-based photo-graphs to increase their longevity. Image-editing applications have options to tint black-and-white photographs either with a preset button or with specific controls to adjust the color of the tone you wish to apply. You can also try toning photos using the aforementioned color-balance tools.

Here, the photograph of Muldoon is a straight conversion. You probably agree that the photo-graph works better in color because Muldoon's coat really pops against the monochromatic scene behind him. In black-and-white, he looks a bit forlorn; and he also gets somewhat lost in the background.

Cropping

Capturing what is essential in your photographs, whether you shoot it that way or crop it later, can help increase the power of the image.

This is where we can leave the intricacies of color balance and tonality and go back to what makes a successful image: composition. And this is based purely on your own aesthetic preferences. Don't be afraid to leave behind the traditional shape of a photograph as well. For example, you can create a panoramic image simply by cropping the top and bottom of the image. Or you can crop your photo to a perfect square. The 35mm frame may not be the best shape for your photo, and there's no reason to

be limited to it. Film is still available in a horizontal format (35mm), a square format (2 1/4 inch film), slightly vertical (4x5), and large format (8x10). Experiment with your image-editing software to see the different effects these shapes can have on your picture. And revel in the fact that you can choose a shape *after* you shoot a picture.

The cropping tool is straightforward. You can use it freely, or with some applications you can set specific ratios so your final image is cropped to a certain shape, such as an 8x10 print. Be sure to read the "Popular Photo Print Sizes" sidebar in Chapter Four when considering your cropping choices.

Sharpness

Sharpening a photograph digitally with a few simple tools will allow many small details to flourish within the image, often resulting in a few wows when you show it to friends. Even a clear photo will often be improved by a bit of sharpening.

Sharpness involves a trade-off with the graininess or "noise" in a photograph. If you use too much, you'll see the image begin to breakdown and lose its smooth tones.

Dodging & Burning

Done correctly, dodging (lightening an area) and burning (darkening an area) a photograph are darkroom techniques both difficult and time-consuming to master. To lighten an area, you would place something to temporarily block—or dodge—the light from hitting the photo paper when making the print, thus lightening the area relative to the rest of the print. To darken an area, you would only allow light to reach the area you wanted to be darker. It used to be a job for a few, hardy darkroom experts.

Our eyes are generally attracted to the lighter parts of a photograph than to the darker areas. This is good to keep in mind both when shooting and when using these tools. A common type of dodging would be to lighten a person's face and bring out more of their features. But burning portions of the image that are bright and distracting to the main subject can also be effective if done well.

Here we chose to dodge Muldoon's face to try to bring him forward from the background. It gives the effect, almost, of a small, overhead porch light shining down on him.

However, this particular tool should be used sparingly. A little tinkering with brightness and contrast is a more successful route to a better photograph. And a whole lot easier to accomplish well.

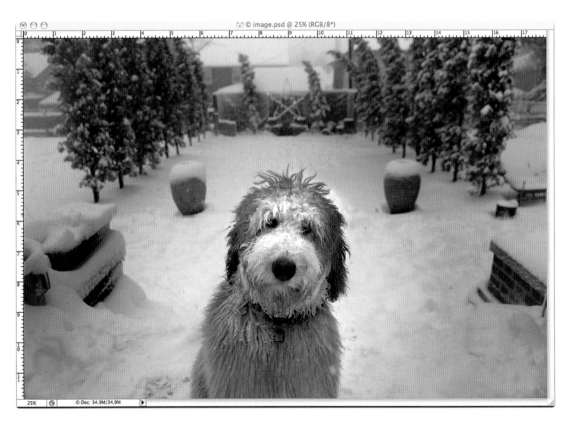

EDITING SOFTWARE

These applications by manufacturer are in order from simple to more complex:

Simple: offer one-button, quick fixes for common problems and enhancements

Enthusiast: more-refined and in-depth enhancements, while keeping easy controls

Advanced: more technical controls that mean more precision and control of your image enhancements; offers both expert controls as well as easier-to-use versions

Expert: has features that a professional photographer would require, such as advanced RAW processing, color-balancing tools, and sharpening, all with controls that are less intuitive but more precise

*We have also attempted to put a price range in dollar signs:

Under $50 is $; $50 to $100 is $$; $100+ is $$$; and $200+ is $$$$.

Google Picasa free/simple to enthusiast

A top-rated image-editing application because of its ease of use, nicely designed interface, and coolness factor. You can export photos to your TiVo, make picture collages, and create giant posters from your own printer by making image "tiles" from one photo. But its best selling point might be that it's free from Google. (Windows)

Apple iPhoto $$/simple to advanced

A nicely refined, clean and simple interface combined with powerful features. Offers many adjustments and makes it easy to order prints, create books, e-mail your photos, and back them up. Comes as part of Apple's iLife suite of applications. (Macintosh)

Corel SnapFire Plus $/simple to enthusiast

SnapFire Plus has tools aimed at having fun. It's for those who don't want to mess around with anything technical and want to get straight to the good stuff. You'll find tools designed for teeth whitening and painting on a tan, and easy editing options such as "Quick Fix" and "Photo Doctor." (Windows)

Corel Paint Shop Pro Photo $$/simple to advanced

A popular, cheaper alternative to Photoshop that can be used by beginners and experts alike. It consistently gets high marks for its ease of use and powerful features. Many traditionally complex editing tasks have easy-to-use interfaces, while still maintaining more precise adjustments. (Windows)

Microsoft Digital Image Suite $$/simple to enthusiast

Uses the familiar Windows task menus to automate editing functions, which can be good for simplicity but tedious if you're working on many photographs. It also includes advanced tools for more user friendly control of image editing. Its Digital Image Library makes it easy to catalog and organize all your photos and videos. It's a good choice if you want to stick to a Windows look and feel, but there are better choices if you see yourself expanding your abilities. (Windows)

Adobe Photoshop Elements $$/simple to advanced

A junior version of the King Kong of professional photo-editing applications. More complex than other applications but offers more accurate and sophisticated controls. It's a good way to learn the essential principles of Photoshop before making a plunge into the main program. (Macintosh or Windows)

Adobe Lightroom $$$$/advanced to expert

Similar to Apple's Aperture (see below) in concept, Lightroom is also a cataloging and processing application designed to speed along a photographer's work flow in dealing with many images, raw processing, and precise and advanced adjustments. (Macintosh or Windows)

Adobe Photoshop $$$$/advanced to expert

Standard issue for professionals and advanced amateurs. Offers some simple features but requires a fair amount of knowledge to use effectively, and has a hefty price tag as well. If you can spend time learning its tools, it offers unparalleled features, precision, and flexibility. (Macintosh or Windows)

Apple Aperture $$$$/advanced to expert

Aperture and its Adobe counterpart, Lightroom, are "work-flow applications," aimed squarely at professionals and serious enthusiasts. Aperture is iPhoto's overachieving, hyper-educated sibling designed for editing and developing large numbers of images, especially those shot in raw mode. It requires modern, high-end Apple hardware as well. (Macintosh)

A lifetime of memories is spread out at the 50th birthday party of Charles DeVries, a Sartore family friend.

Chapter Four
PRINTING, DISPLAYING, AND STORING YOUR PHOTOGRAPHS

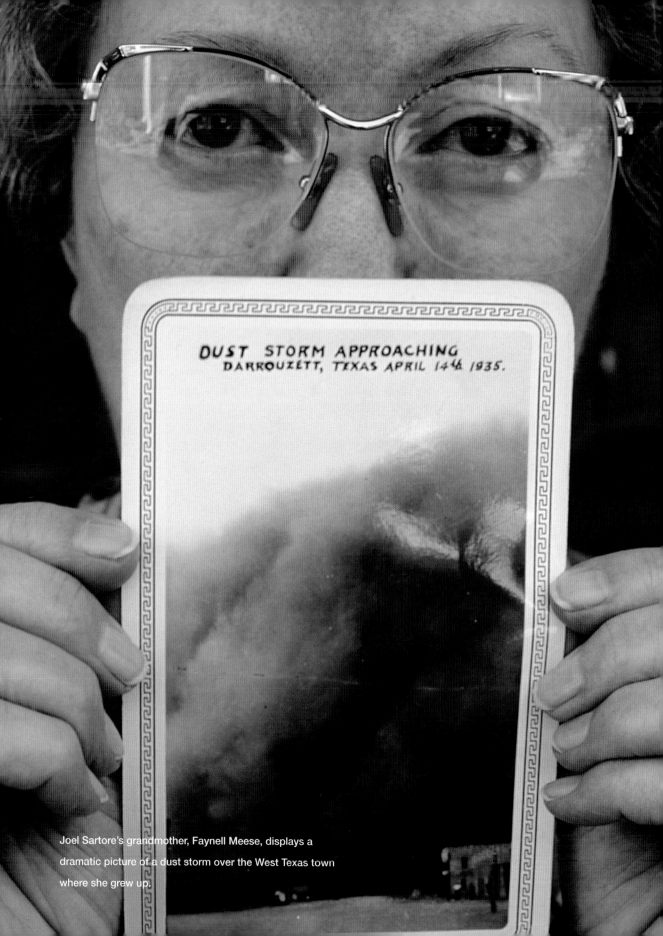

DUST STORM APPROACHING
DARROUZETT, TEXAS APRIL 14th 1935.

Joel Sartore's grandmother, Faynell Meese, displays a
dramatic picture of a dust storm over the West Texas town
where she grew up.

PRINTING, DISPLAYING, AND STORING YOUR PHOTOGRAPHS

This may not occur to you at the time, but the photographs you take of your family will be remembered for generations. Thinking about your photos in such a way, especially while making them, will give you compelling ideas about what to photograph. And what to keep.

Preservation is as much an artistic endeavor as it is an organizational tool. Which pictures become the ones family members remember and why? Do you frame these? Or upload them onto a website people can access? Is a digital archive more user-friendly or do you need a photo album to organize your pictures? Are prints longer lasting than CDs?

In this chapter, we will discuss the many ways you can organize your photographs so you can appreciate them and preserve them for as long as you like. We begin with the differences between professional printing and home printers before we go into the myriad ways to display and/or show your pictures, including homemade books. Finally, we give some pointers on archiving, whether you have digital files or fine-art prints.

Printing

A traditional (or "conventional") print is made using paper coated with light-sensitive silver (impress your friends by calling it "silver-halide printing"). Whether you're a famous photographer returning from covering dignitaries or a mom returning from the wilds of the local zoo, your photographs are printed using the same high-quality silver process. Done correctly, these prints have wonderful tones and last for a very long time.

Now that it's possible to make your own prints at home, should you? If you like to tinker and you enjoy installing print drivers, loading color cartridges, and making test prints, and you deal well with moderate-to-high levels of frustration, by all means, dive in. But if you want really good quality prints quickly and at a reasonable price, stick with the professionals: your local or online lab.

Photo labs have the definite advantage over home-based printing. Most of the larger online and local labs use a printing method that mixes

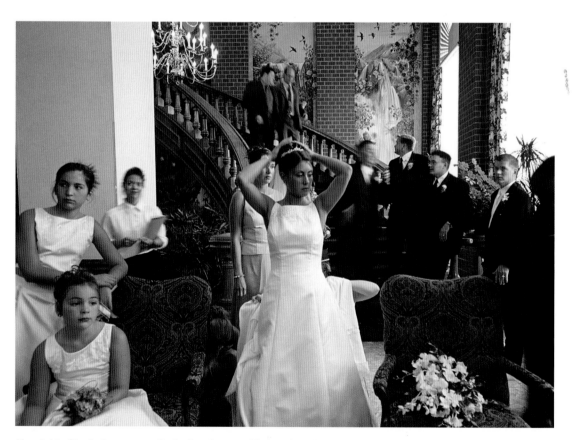

New bride Stacie Swanson waits for her dress and hair to be adjusted just before her wedding reception. I made this photograph using only the available ambient light in the room.

the best of the new and old schools of photography: They print digital photographs onto traditional silver-based paper using lasers. This means you get the convenience of a digital camera with the long-lasting, better-looking, traditional prints. This process also requires less resolution to print good quality photographs than most home printers do. And it's pretty hard to beat the prices of many online labs.

At the outset of the home photo-printer phenomenon, few people were questioning how long their prints would last. It was good they didn't. Many of the prints were showing extreme fading and color degradation after two years or less. As technology has improved inks, papers, and printers, this has changed—but only if you make the right decisions regarding the three. There are many printers, papers, and inks that will fade considerably after one year. After five or ten years, you may be left with more paper than photograph.

There are no industry standards for how long photos will last, so while you may be making "photographic quality"-looking prints, you may not be making prints with the longevity of a traditional print. There are, however, archival-quality inks and papers, which are available mostly at photography and other specialty stores. These are a good idea for printing photos you wish to keep for a while; but they have premium price tags. A good online resource for gauging how long combinations of printers, paper, and ink might last is www.wilhelm-research.com.

PRINTERS FOR THE HOME

Traditional silver prints, whether made from a film or digital original, are the standard by which home-printing technology is measured. Photo-quality printers generally will produce prints similar to a traditional photographic print in quality. True photo printers supposedly produce photographs that are indistinguishable from a traditional print. However, there is wide latitude for the term "photo" when applied to a printer. It certainly doesn't guarantee the same quality as a traditional print. Lesser printers may make prints that approximate, at best, that standard.

There are three types of printers for printing photos. Ink-jets are by far the most popular. These printers use many tiny and amazingly precise nozzles to apply ink of different colors onto photo paper. Within the ink-jet family, there are two divisions: those ink-jets specifically designed to print photographs; and those designed to both act as general-purpose printer and to produce photo-realistic prints. Generally speaking, printers specializing in photographs will do a better job, but some printers are equally adept at serving both daily-use functions (printing e-mails, documents, etc.) and printing great-looking photographs.

Higher-quality printers produce better prints by using more nozzles, a larger variety of ink colors, and technologies that intelligently apply the ink to achieve the best results. These three factors contribute to producing finer gradations of color and tone, which is the best way to approximate a traditional print.

Base models might have three-color cartridges and cost less than $100. High-end models will have six or more colors and have individual tanks for various shades of blacks and grays to achieve natural-looking black-and-white photographs. But beware the price tag on printers. They may seem cheap, but you'll quickly spend

a lot more money on ink refills than the original price of the printer.

Other options besides ink-jets are thermal and laser printers. Thermal printers use a completely different technology than ink-jets. Instead of nozzles, these printers use a ribbon that contains three colors; and color is laid down layer by layer onto specially coated paper. This process comes closest to mimicking a traditional print because it is a truly continuous tone process. The end result looks and feels very much like a traditional print, thanks to its final, protective coating. The ribbon, however, must be the same size as the print; so sizes are usually limited to 4x6 inches. But the quality is generally excellent.

Laser printers are another option. They aren't usually designed for printing photographs; but their resolution is often high enough that, if you use special photo-laser paper, the quality can be photographic in nature. However, paper choices for laser printers are limited in comparison to ink-jets.

It is not recommended that you judge a printer by its numbers—print heads, nozzles, or resolution. Printer resolution is an area that can be a bit confusing and misleading. The resolution refers to the number of dots per inch the printer is able to print—the more dots generally leading to a more photographic-looking print. Ink-jets are capable of finer resolution vertically (lengthwise on the page) than horizontally. So you'll see a photo printer's resolution stated as 1,200 by 4,800 dpi—or 1,200 dots per inch horizontally and 4,800 dots per inch vertically. Newer ink-jets are able to make better prints with less resolution through software and advanced printing techniques, so it's best to see the actual output and judge for yourself. If possible, take some of your own photos into the store and print them. Use the numbers as a starting point for which printers to use for test prints.

INKS

If there's a time to stick to the manufacturers' recommendations, it's when choosing photo inks. Ink-jet printers are remarkably precise instruments. The proper functioning of their software and technology depends completely on their ink cartridges working exactly as the manufacturer intended. Combining the original ink cartridges with paper recommended by the printer's maker will provide the most-predictable and best-quality results. Using high-quality ink is also the best way to ensure that prints will not fade or change colors over time.

POPULAR PRINT SIZES

4X6	67 percent, or the same as a 35mm frame
5X7	71 percent
8X10	80 percent
16X20	80 percent
20X30	67 percent, or the same as a 35mm frame

PRINT SIZES

One might assume that the popular print sizes available are the sizes of the photos your camera

takes. But, alas, they aren't. If you were to make a print of a standard 35mm picture as you took it with your camera, it would be 8x12 inches, not 8x10 inches.

To print your picture on an 8x10 piece of paper, you'll have a choice to make. You must either crop two inches off the length or width (whichever is 10 inches long), or you have to print it smaller than 8x10 on the paper so you can fit it all on the page. This is the case with every print size except for a 4x6 inch or 20x30 inch print, which is the same ratio as a 35mm frame. (See chart at left.) Some photo labs now print at the same ratios as the 35mm frame; but finding frames or albums that fit these photo sizes can be hard.

PAPER

The media available for use with ink-jets is, quite simply, amazing. There's everything from standard, glossy paper to simulated-fiber paper (fiber paper is regarded as the finest paper for a true silver print). Darkroom-type experimentation is still alive and well, even with this technology. Every printer prints better with some papers than others. Often, it's easiest to stick with paper produced for your specific brand of printer, but a bit of experimentation can lead to some excellent results as well.

A paper's thickness is described as its weight. Thicker paper has a higher weight and is more durable and has a feeling of quality and longevity.

How bright or "white" the paper is will affect the colors and tones of your prints—whiter being preferable for snappy contrast and vibrant colors. But "warm" papers—those that are ever-so-slightly yellow in color—can give prints a richly toned look.

Modern color printers can have as many as 6, 8, 10, or 12 colored inks, providing a large color palette from which to print.

The paper's surface, whether glossy, luster, matte, or another kind, affects how the ink reacts to the paper. Glossy surfaces are the best choice for good contrast and a colorful image with a broad range of colors. Matte paper absorbs more ink and has its own unique look and feel. Luster or semi-matte can be a nice compromise between the vibrancy of a glossy print and the subtle, rustic feel of a matte print. Still, there's no clear winner here. Just use what you like best.

RESOLUTION

Resolution has to be the most misunderstood and abused term in photography. The problem is that the term is used in many different ways and often not correctly. This wasn't an issue with

(such as in this book), you'd need a higher image resolution. But for bigger online labs and prints from an ink-jet printer, you'll be covered.

All you really need to know is that for prints, more resolution is required. For display on a computer screen or TV, less is required. So it's best not to send the full-resolution file to your friend via e-mail—unless you want them to be able to make a print from it. If you're still curious or really want to talk the resolution talk with your local lab, read on.

THE DEFINITION OF RESOLUTION

Resolution is the degree of detail visible in a single image. A "high resolution" image will have very fine detail, whereas a "low resolution" image will not. If you look out a fogged windshield in your car, you're seeing a low-resolution image of what's outside. Cars are vaguely discernible blobs of color; trees are modern art. Turn on your defroster and, as the windshield clears, you'll see more details. Once it has cleared, you'll see a high-resolution image out your window.

Another way to understand this concept is to analyze a billboard. Seen from hundreds of feet away, a billboard can look photographic in quality. But if you were to see it up close—say, from three feet—you would see nothing but giant, golf-ball-size dots. The print resolution of a 14-foot-by-48-foot billboard is something between two and 20 dots per inch! That's because the more closely an image will be viewed, the more discerning we are in viewing subtle gradations in tone—hence, more dots required per inch. By comparison, a popular magazine will be printed at 300 dots per inch.

Shoeboxes and messy drawers are unfriendly places for long-term storage of your photographs. Try to establish a method for archiving and stick with it.

film cameras, but a digital photograph is made up of lots of little electronic dots, or pixels. A pixel doesn't exist beyond your camera or computer; when printed, pixels are changed into dots. These millions of dots are used with machines that print the images.

Do you need to know all about resolution? No. Not if you have a camera that's 3MP or higher. That's enough resolution for most prints you would make at home or in a lab. True, there are printing methods that require higher image resolution. Your local lab's printers may require higher resolution for an 11x14 print, for example. And if you were having something commercially printed

THREE TYPES OF RESOLUTION

In photography, there are three kinds of resolution you're likely to encounter: Camera resolution, image resolution and print resolution. The first two are electronic and are measured in pixels. The last, print resolution, is based on printing on something—such as a piece of paper—and that's measured in dots. A dot can be considered the real-world equivalent of an electronic pixel.

Camera resolution refers to the number of total pixels your camera is able to capture in an image at its highest-quality setting. This is what the megapixel moniker refers to. Because there are so many pixels, manufacturers began using the term "mega" for "millions." So a one-megapixel camera captures 1,000,000 pixels, and a four-megapixel camera captures 4,000,000 pixels. This measurement refers to the total mathematical area (length multiplied by width) of the image. A 1MP image is 1,232 pixels wide and 824 pixels high. Multiplied together, they total 1,015,168 pixels. (The numbers are rounded for ease of use.)

While it's true that more camera resolution is a good thing, the optics, sensor types and internal software are extremely important to image quality. An image made with a professional-level 4MP digital camera and a top-of-the-line lens will have better clarity, color and tones than an 8MP camera that has inferior optics and sensors—just as using more paint of an inferior quality won't get you a better-looking wall.

Image resolution is the number of pixels in a specific photograph. That may be equal to your camera resolution if you have your camera set to its highest-quality setting. But if it's not set that way, that total number of pixels may be lower.

Print resolution is the number of dots per inch that are being printed to a page, the more

WHY DOES A PRINTED IMAGE LOOK DIFFERENT FROM THE IMAGE ON MY COMPUTER SCREEN?

Why can't I print what I see on my screen? Why does it look so different when I print?

If you're looking at your photographs on a computer screen, that screen uses 100 or fewer pixels per inch to show you a photograph. Why so few? Because there are far more colors and tones possible in a given area than even the most expensive printer is able to print. This means subtle details can be rendered with less resolution, or fewer pixels.

Also, the technology your display uses and the technology your printer uses are very, very different.

The translation between the two has gotten a lot better because of software advances, but don't expect your printer to perfectly duplicate what you see on the screen.

Your display may not be showing colors correctly, either. To correct this, you can calibrate your monitor with a device that reads the monitor's colors and with software that interprets it. But if you're using a monitor that is less than three years old or relatively modern, then chances are it'll be somewhat close.

dots meaning a higher resolution image. The more dots per inch required to print, the more pixels you will need to print at a given size.

Let's say your printer requires 200 pixels per inch to print a photograph correctly. Why? It has a minimum, just like you'd need a minimum amount of paint to cover a wall. Any fewer pixels per inch and the print would seem choppy and "pixelated." But more pixels per inch won't make the image look better. The good news is that modern printers take whatever size file you have and automatically convert it to its best print resolution. Also, the printer's resolution (the numbers plastered all over the box when you bought it, not the print resolution) doesn't equate to the image resolution.

As an example, assume you have a 3MP camera, or roughly 3,000,000 total pixels in the image's rectangle—that's 2,128 pixels wide and 1,416 high.

To know the biggest print you can make on your 200-pixel-per-inch printer, you figure out how wide it can be (2,128 pixels divided by 200 pixels per inch = 10.64 inches) and how high (1,416 pixels divided by 200 pixels per inch = 7.08 inches). You can make it bigger, but the image detail will decline.

HOW MUCH RESOLUTION DO YOU NEED?

For printing at most professional labs, you don't need so much resolution. Kodak's minimum for a good quality 8x10-inch print is a paltry 1.3 megapixels. For a 20x30-inch print, they call for 2.2 megapixels. They are quick (and correct) to point out that this is image resolution, not camera resolution.

This photograph is pixelated because it has been cropped and blown up to a size that is larger than the original file size can accommodate.

Just remember—a three-megapixel camera can be set to a lower quality level, which means it will be making files that may only be one megapixel in size. (This setting is available on your camera to make file sizes small enough for the Web, not a photographic print.) The only way to make a one-megapixel image into a two-megapixel image is to spread out the pixels. When you spread the pixels, you risk creating a grainy-looking, lower-quality print.

In summation, if you think you will be making lots of 8x10 prints for your family and friends, start with a six-megapixel camera. This file size seems to make pictures that print well at the 8x10 print size. Keep the file-size quality setting on "High" for photographic prints and "Low" for JPEG attachments in e-mail. Remember to check occasionally that you have the setting you want when you are shooting. Image resolution is different from camera resolution and the difference will show only in your prints!

Displaying Your Work

Photographs are essential to recording history. Few families have written accounts of their history. Photos are invariably what gets passed down over time. Keep this in mind when creating and storing photos. The time you put into albums can be both a fun way to express your creativity and also an important, intimate legacy for your family. And spending time and money on your family's memories can be one of the most rewarding and enjoyable things you can do.

First, forget what you know about traditional photo albums. You know the ones. They hold nothing but 4x6-inch pictures and have ugly covers made of green leatherette. You've had to sit (yawn) through seeing (yawn) your friend's photos that show you this person at a party and this person on a trip. Your photos deserve a better fate.

The key to creating an interesting photo album is to approach it as a photo editor would. You want to think about the book as a whole and arrange photographs in a way that's interesting. You can find great inspiration in photo books at libraries and bookstores, and you see how the professionals do it.

Like a written book, photo books seek to keep the reader engaged. There is certainly no right way to do it; but there are ways that work better than others. Some books will have very simple layouts with lots of space around the photographs (known as white space or negative space). Photographers write captions to accompany the photographs. On the other extreme are photo books that resemble visual journals. They are awash in photographs, clippings, drawings, notes, and anything else that fits. And then there are those in the middle that have large, full-page photos on one page and smaller photos on the next.

Experiment with your books by mixing black-and-white photos with color, using different sizes and orientations (horizontal and vertical photos) throughout the pages. A key to the books also is to edit your work so the idea of each photo isn't redundant throughout a page. A photograph can be striking on its own, without similar others you snapped. Pick the best one and let it make a strong statement.

Of course, once you've experimented with the basics, it's time to break the rules. Some of the most revered artwork has both followed rules and thoroughly broken them; and your albums

Print Size	Minimum Recommended resolution (pixels)	Equivalent dots per inch
4x6	930x620	155 dpi
5x7	1000x720	144 dpi
8x10	1280x1024	128 dpi
16x20	1500x1200	75 dpi
20x30	1800x1200	60 dpi

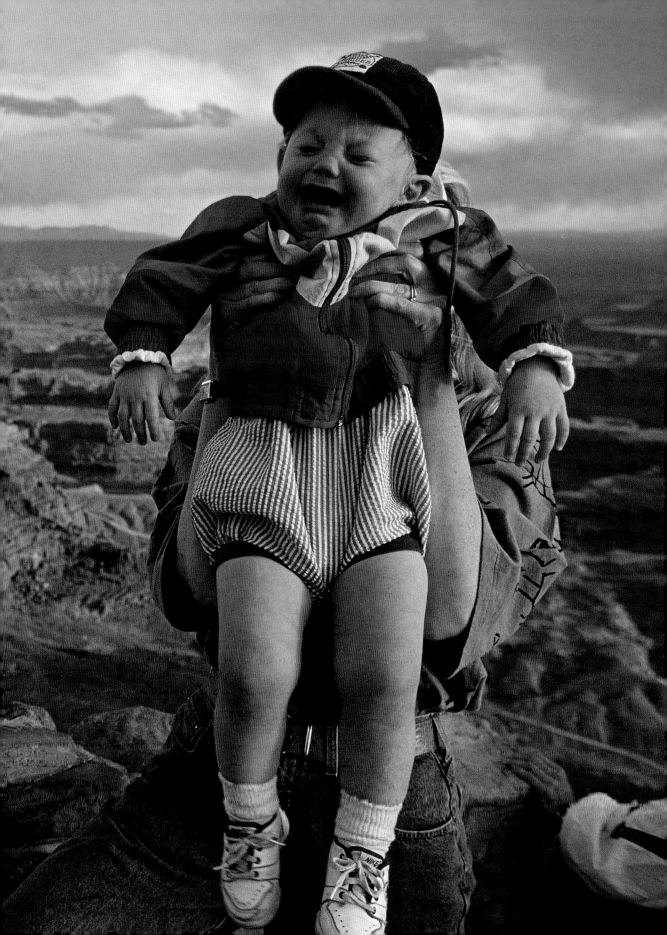

...from a perfectly good evening. He was eight months old and I was shooting a story on Utah for National Geographic. At least I got a picture out of this event.

HANDMADE BOOK SOURCES & INFORMATION

Under the umbrella term of "book arts," the craft ranges from kits for beginners to the art and science of conservation and creating authentic books of bygone times.

www.colophonbookarts.com
www.plickityplunk.com
www.philobiblon.com
www.paper-source.com
www.neverbook.com
www.centerforbookarts.org

The Bookmaking Kit, by Ann Morris and Peter Linenthal
Cover to Cover: Creative Techniques for Making Beautiful Books, Journals, and Albums, by Shereen LaPlantz
Bookworks: Books, Memory and Photo Albums, Journals, and Diaries Made by Hand by Sue Doggett
Handmade Books & Albums, by Marie Ryst
Creating Handmade Books, by Alisa Golden
The Penland Book of Handmade Books: Master Classes in Bookmaking Technique, by Lark
The Handmade Book, by Angela James

...should be such a learning experience. If you have a fun sequence of images—maybe your child throwing a tantrum (although it wasn't fun at the time)—try getting small wallet-size prints of the whole series of photos and putting them like a movie across the pages. No matter what you come up with, it will not only be fun to make but in time will be fun to remember.

COMPUTER-MADE BOOKS

Many online labs as well as photo applications allow you to create a photo book on your computer. These services and applications use professionally designed templates that are as easy as drag-and-drop. The ease of creating these books is astonishing, and the prices are often not that much above what an empty album might cost. If possible, look for labs that use archival, acid-free paper.

HANDMADE BOOKS

If there's a reason to make a handmade book, it's that it doesn't involve a computer. We use technology for so many tasks today that we forget how personal—and appreciated—something handmade can be. The uniqueness of something created by you is truly special.

Book making can be as simple and cheap or as specialized and pricey as you want it to be. Covers can be made from used boxes, and bindings made with kite string. Or you can find exquisite handmade papers, cloth, and leather. And with no computer involved, the only "minimum system requirements" are opposable thumbs and a desire to have fun.

There are kits available that contain everything you need and books that offer detailed

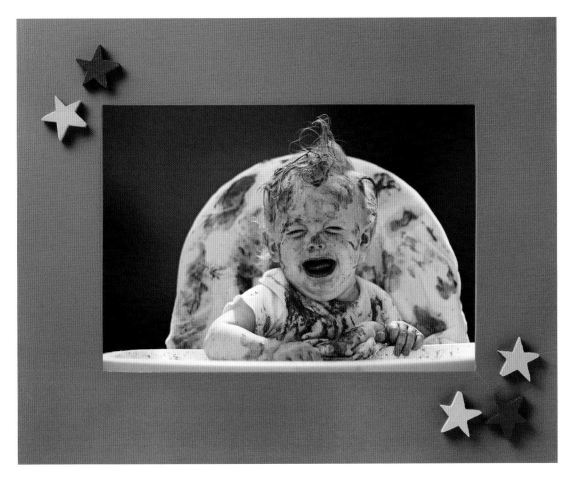

Frames are a good way to protect photographs from dust and scratches. Make sure the glass you select protects photographs from direct sunlight, as well. Colors can fade over time.

instructions and lists of required materials.

Another creative idea is to make a book and involve your kids in the project. An excellent online resource for simple, fun ideas is Susan Kapuscinski Gaylord's Web site, *www.making-books.com.* The site, titled "Making Books with Children," was created by Gaylord, a parent, educator and artist. She started making books as her own art and soon thereafter began making them with her children. She now teaches classes on making books with children in schools, libraries, and for families.

Susan believes in books as a way for children to make their own words, pictures and drawings special by creating everything themselves. As a parent, she saw the media-saturated world kids grow up in and has witnessed how making books engages them in their own unique lives and skills. She has seen how they rise to the occasion at the idea of their very own book, and how that idea will spur their creativity and enthusiasm. The whole process is a lesson in listening, following directions, attention to detail, and learning how small steps make a big result. Taking pictures for your child's book will inspire you to look beyond what you usually see, too. What's

The Sartore family keeps many family photos framed and on display. Other photographs are stored in photo albums and scrapbooks directly below in dust-free cabinets.

important in their world, and how do they see?

There are also artisans who make handmade books to which you can add your own photographs. Their skill, attention to detail, and knowledge of materials can add up to an exquisite showcase for your family's memories (not to mention for your prowess as a photographer).

FRAMING

Frames are a good choice for keeping photographs in good shape for several reasons: They protect photos from dust; the rooms they are displayed in are generally kept at temperatures and humidity levels comfortable for people and good for the prints; and you can enjoy them on a daily basis.

Because most homes with children are full of stuff, it's a wise idea to pick simple, clean photographs to put on your walls. Choose photos that

have lots of white space and a clean, uncluttered subject. Black and white is popular in framed work because it supports this approach.

I don't recommend that you permanently mount prints to framing materials. This could mean problems down the road if the print must be removed, the framing material is not archival in nature (acid-free), or the mounting surface is damaged in some way.

Find frames that use UV-coated material to cover the print (known in the industry as glazing). Ultraviolet rays are the chief cause of faded prints.

If you are serious about keeping a print for a long time and also want to frame it, consider using a framer who specializes in conservation printing. These framers use specialized, archival materials made especially for photographic prints. Their work is expensive but you will be sure your photograph is preserved forever.

Storing

Most digital photos end up on compact discs or DVDs. Caring for these is a straightforward process, but it's important to follow some basic steps to ensure they last a good long time.

DVDs and CDs are known as "optical media," not because you can store photographs on them but because of the way the hardware reads a disc. Lasers aimed at the discs and the computer read what is reflected back. Thus, it's quite important to keep not only the bottom—the data side—of the disc clean and scratch free, but also to protect the top of the disc from any damage that might make it unreadable.

Some rather common ways of labeling these discs are not recommended, however. Writing with a standard, permanent marker may cause the reflective top coat of the DVD to slowly deteriorate. And stickers, whether standard labels or those specifically designed for discs, have also been known to degrade the top of a disc. So what do you use? Special CD/DVD markers made specifically for this purpose, with no solvents or other ingredients that could cause damage to the discs. A better option would be not to write on the disc, instead labeling the outside of the jewel case or writing on the paper slip inside the case.

Where and how you store the discs is probably the most important consideration to their longevity. Store them in their jewel cases upright (not lying flat) in a cool, dry, and dark area where the air is clean. (A damp basement or a hot attic is not a good idea.) Popular books and paper sleeves may be tempting and may be fine for short-term storage, but the plastics and inks used in these products can be unfriendly to discs. They also don't allow air to circulate freely around the discs. Books of these discs inevitably end up lying on their sides, often with other things stacked on top of them. Over time, this weight can distort the discs and make them unusable.

USING HARD DRIVES AS STORAGE

Storing your work on your computer's hard drive or an external drive is a quick way to keep lots of photographs at hand but by no means a fail-safe storage option.

Hard drives fail, often without warning, and getting information off of them after the fact can

ALBUMS, JOURNALS AND SCRAPBOOKS

www.priscillafoster.com
www.eidolons.org
www.galleriamia.net
www.gracialouise.com
www.dreamingmind.com
www.alisonarts.com
www.k-studio.com
www.chroniclebooks.com
www.kolo.com
www.amandbooks.com
www.soleberry.com
www.bookjournals.com

be difficult and expensive. Therefore, it's best to make copies of your photographs on a CD or DVD, or onto a second hard drive that you plan to use as an archive/storage drive. The goal is to have at least two copies, so you'll have a backup if one fails or is damaged.

An external archive drive (that attaches via USB or Firewire) should be connected and plugged in to a power source only when it's in use. Keeping it unplugged minimizes the possibility that power surges will damage it. When it's not in use, keep it in the same conditions as your photographs: a cool, dry place where the air is clean. Protect it from dust by keeping it in a container (its original box is a good idea).

Another option is online storage. There are many companies that will store your images after you've sent or uploaded them. This is a good idea for many reasons: It provides easy access to your photographs; there's no equipment to buy; and if something happens where the originals are stored, these will be safe.

Finally, the most important piece of advice we can share with you about digital archiving is to make two copies of everything—CD+hard drive, or print+CD, or two hard drives, for example. This way if one storage solution is corrupted, you have the photograph available to you in another place. A corrupt file is a lost photograph.

Electronic archiving can be as simple as pressing a button to transfer photos from your camera into your computer. Devise a sorting system early or it will be difficult to find photos later.

A Good Idea for the Future: Prints

One issue with archiving digital photographs on electronic media is that the technology for storing the data—whether optical, on hard drives or any other way—is constantly changing. And how these storage methods will last over time is anyone's guess. It's certainly not like having a negative stored in a file cabinet. (Joel, for instance, stores his film photographs in archival Tyvek plastic sheets and filing boxes.) That technology may feel outdated, but its simplicity and easy accessibility seem enviable in this digital age.

Also, in twenty years, the likelihood that a hard drive, DVD, or CD can be readily accessed by the current technology is fairly small. You must know this already by the rapid changes in camera technology and cameraphone technology that are happening year by year. This is why making prints, photo albums, and books is a good idea. There's no technology needed to access them, and, stored properly, they will last a long time.

Proper storage involves three factors: cool temperatures, a dust-free place, and air circulation. Inside a shoebox in a hot, steamy attic with the windows closed is not a good option. Try to pick an accessible place that you can monitor easily. You don't have to be as high-tech as a photo archive with refrigeration rooms and high-priced servers in temperature-controlled rooms, but you do need to be diligent if you want to keep your photographs for the next generation.

There is no one solution, as you may have guessed in reading this chapter, but we hope we

ONLINE PHOTO LABS

Most major, online print labs use traditional, silver-based, photographic paper from either film or a digital image. The prints are made with a high-tech process that uses lasers to record your image onto traditional photographic paper. Great for archiving, this method also requires less resolution than an ink-jet printer. This means better-looking and bigger photographs all around. Many of these services also offer to store your photos—some for free, some for a fee. This is an easy way to backup your work.

www.kodakgallery.com

www. mpix.com

www. snapfish.com

www. ezprints.com

www. smugmug.com

www. shutterfly.com

www. photoworks.com

www. imagestation.com

www. fototime.com

www. dotphoto.com

www. pictures.aol.com

www. photos.walmart.com

www. phanfare.com

have offered several choices that will help you decide a plan of action. The biggest reason we have this archive to share with you is we worked to create it. And we take care of it, too.

Joel Sartore inches his way toward a juvenile caiman in Bolivia's Madidi National Park.

Chapter Five
CHOOSING YOUR EQUIPMENT

A painter's scaffold cabled to the trees provided a perfect, though swaying, photo platform above the canopy in the Bolivian Amazon.

CHOOSING YOUR EQUIPMENT

Your camera is a tool—a tool you'll be using to record the big and small moments in your family's lives. As with any tool, learning how to use it well is the best way to make it work well for you.

Remember that: the camera works for you. You're the boss. One of the things professional photographers loathe hearing is, "Wow, you must be able to take great photos with that camera." In fact, no. The camera doesn't take a good picture. You do.

Your ability to see—or, more accurately, to be visually literate—is the key to taking better pictures. Because of the technical details involved in snapping pictures, there's a tendency to think the camera has a bigger role than it actually does. While any equipment chapter must address the technical details, we can't emphasize enough the human element.

You may be using the most-expensive and most-advanced camera in the world, but if you're not really seeing your subjects, your pictures will show it. We can tell you what to look for in a camera, but you have to spend more time learning what to look for in your photographs.

How to Choose

The first points to consider about a camera are—realistically—how you're going to use it, and how technically minded you expect you'll be about your photography. If you don't want to lug around a big camera, you should probably be looking for something small that fits in a pocket or bag. If, however, you don't mind carrying around a bigger model and think you could get into some more-advanced features, then you should begin your search at something beyond the basic point-and-shoot models.

The next thing to do is see how the camera fits in your hand, and, even more important, if you can turn it on. Are the controls intuitive or are they too small and hard to read? Seriously, you and your camera should be agreeable to each other. If not, you either won't take pictures, or you'll miss them while fumbling about for the *on* switch. Try several different models—some are clearly more user friendly than others.

WHERE TO BUY

There are a bunch of cameras out there and even more places to buy them. A good rule

Rancher Happy Shahan takes Joel's picture on his South Texas ranch. During the 1950s, actor John Wayne filmed *The Alamo* here.

of thumb: Get a camera made by a name you know. If the company also makes high-end gear, then it's a safe bet that their lower-rung models will offer good quality and be user friendly.

Camera retailers and used-car dealers must share notes, because they each have equally bad reputations. Look in any big photo magazine, and you'll see pages and pages of ads for ever-lower prices on cameras and camera gear. But in many cases, you might find ethics as low as the prices. Before you purchase from a retailer you don't already know, do an Internet search on them. Better yet, find the local camera store the professionals use. Chances are they'll sell non-professional cameras as well. Don't feel intimidated. Hobbyists are generally their bread and butter and are therefore very welcome in the stores.

MORE ISN'T ALWAYS BETTER

Although it may make you look like a great photographer, big, fancy equipment won't necessarily make you one. In fact, if a camera seems too heavy to carry with you, it probably is. If it seems too complicated to master, it probably is. End result: fewer pictures.

The best camera in the world won't do you any good if you never have it with you. Rules one and two of camera buying are simple: not too big, not too expensive. It's best if you can toss it into your pocket or bag with no worries. And with the money you save, you could afford one for home and one that goes with you.

Professionals use expensive cameras for essentially one reason: They are reliable. When the mortgage, dinner and college tuition (never mind the art) all depend on a camera working

flawlessly—and you get only one chance with your subject—the camera better be perfect. These cameras also tend to be better able to take a beating than less-expensive models.

Point-and-shoot cameras

Point-and-shoot cameras have traditionally suffered from lackluster performance. Their lenses were bad, they were cheaply built, and you could barely see through the viewfinder—not to mention some pretty lousy image quality. But that has changed. Better point-and-shoots can now be had with high-quality lenses and bodies that are stuffed with advanced electronics.

These cameras are more convenient to carry but do sacrifice some amount of control for that convenience. For example, you won't find too many point-and-shoots that offer manual exposure modes or manual focusing—something you may want as you become a more adept photographer. Also, these cameras' viewfinders are on the small side, so using the LCD screen on the back will be more practical. Many point-and-shoots are of a type known as rangefinder, which means the viewfinder is giving you an approximation of what the lens is seeing—you're not actually looking through the lens as you would with an SLR (single-lens-reflex) style camera. Depending on the quality of the point-and-shoot's viewfinder, it might not be so easy to see exactly what you're photographing. But if carrying around a larger camera is out of the question, these are good options.

Some professionals are now using the higher-end point-and-shoots on assignments where they need to be discreet and unnoticed, as when working on a documentary.

Single-lens-reflex cameras

SLR cameras have always been the choice for first-rate images. They offer more flexibility, with interchangeable lenses and an array of optional accessories. One of the reasons for an SLR's size is its system of mirrors and prisms that allow you to see through the lens using the camera's viewfinder. This means you see exactly what the lens sees. It's great for taking photographs, it's just not great for hauling around. The sensors on these cameras are generally bigger than a point-and-shoot's, resulting in better overall image quality. The cameras are also easier to hold for long periods of time than smaller point-and-shoots, and their controls quicker and easier to use repeatedly. Among SLRs, there are also digital SLRs (D-SLRs) and the small category of fixed-lens SLR cameras (no interchangeable lenses).

.

Electronic Viewfinder Cameras

Newer technology has resulted in much smaller SLR-style cameras. These electronic-viewfinder (EVF) cameras combine the convenience of a point-and-shoot with the more sophisticated controls of an SLR. With an EVF, you look into a viewfinder as you would on an SLR, but what you see is a digital representation of what the lens sees—with none of the mirrors, prisms or bulk of a standard SLR. While it may not be perfect, it means you can carry around a camera with SLR features (although not the interchangeable lenses) in a smaller and lighter package.

Film still works, too

As popular as going digital is, don't totally aban-don film. Film cameras are fabulously simple, use cheap, readily available batteries, and the film is easily developed—by someone else. Most any size print can be made with 35mm film, so no resolution to worry about. And while the immediacy of digital can be fun, it can also prove distracting. You might spend more time looking at the back of the camera than taking photos. If you have a film camera, use it for a while. Most of the world's best photographs have been made using the stuff.

Try this

Before you decide which options are for you, try this experiment with the most no-frills camera of all: an index card. Yep, an index card. Cut a small, rectangular hole in the center of the card, maybe an inch and a half wide and an inch tall. And voilà. You have the perfect training camera.

Now, look through it. Frame up the dog. Or the fish. Or the clutter on the kitchen table. The idea is to slow down and really think about what you see in your paper camera's viewfinder. And we mean slow waaaaayyy down. Don't expect to see everything you need to within seconds of placing your camera to your eye. Look around. What's in the background? The foreground? At the edges of the frame? Is your subject centered? Should it be? If you turn the camera vertically, does it make a better picture? What if you get down low? Or stand up high? Take a mock picture of a flower, or your child's hand. Is the background clean or cluttered? Does it make sense not to center it? Can you come in really close? Or is it better from a bit farther away?

JOEL'S CHOICES

My preferred camera is a Nikon D3, with a 17-35mm f/2.8 lens. It's Nikon's top-of-the-line camera body, the same I use for my work. Because of that, I know it very well; It's almost an extension of my body. I might take a flash with me as an emergency light source. Having a "fast" lens—one that has an aperture of f/2.8—allows me to shoot without a tripod when the light is dim, and the zoom gives me some flexibility when space is tight.

I use a top-of-the-line camera and lens because they're what I know, not because of some need to have the very best gear. It all can be quite easily replicated with lower-priced equipment. Also, I'm used to having this camera on my shoulder, but it's heavier than any point-and-shoot camera. Most SLRs and many point-and-shoots feature automatic-priority modes (using either shutter speed or aperture). And while your budget may not accommodate an f/2.8 lens, lenses between f/4 and f/5.6 usually are less expensive and smaller, too. You simply increase your ISO settings to ensure your shutter speed doesn't get too slow.

I can hear the camera techies now: "Image fidelity won't be optimal!" "That lens only rated a 6.724 in Modern Techie Camera Review Journal!" Pay no attention. Learn to solve visual problems rather than technical ones. A good visual person can make a great photograph with a lousy camera. The reverse isn't necessarily true.

A veiled chameleon (Chamaeleo calyptratus) poses for the camera at the Rolling Hills Wildlife Adventure.

Basic Features

Your index-card camera is free of blinking lights, beeps, or batteries in need of charging. While it may lack a little something in the area of technology, the fact that you can do nothing but concentrate on what you see is important. The blinking lights, beeps, and batteries will be there soon enough.

The main lesson here is that you, not your camera, will be making photographs. As with the pen to its writer or the instrument to its musician, so the camera to the photographer. It's just a tool, and what you create with it is what counts.

Here is a list of camera features, ranging from what is generally essential to some that are more advanced. All may be found on either a point-and-shoot or an SLR.

Viewing screen or viewfinder

Some point-and-shoots have an LCD screen and a traditional viewfinder. What's the difference? When you're looking at the screen, you aren't looking directly at what you're photographing. A viewfinder, however, forces you to concentrate—just like the fancy index-card camera. The viewing screen also uses a significant amount of battery power, increasing the need to carry spare batteries.

Fixed or zoom lens

There are two types of lenses. Fixed lenses offer one set focal length, usually somewhere between 35mm and 50mm (or the equivalent for the camera's sensor size), and see approximately as your natural vision sees. Zoom lenses are like several lenses in one, and you can adjust how wide (a lower number) or how tight (a higher number) your lens can be.

But a lens can also be adjusted by your feet. What this means is that you can "zoom" a fixed lens simply by walking toward your subject, or you can widen it by backing away from the subject. Using a fixed lens keeps things simple and actually helps you learn to see, rather than complicating things with the almost-infinite number of options a zoom presents. Fixed lenses are faster to use, smaller and lighter.

Beware of two things concerning zoom. First, there's a nasty little thing called "digital zoom," also known as cropping. A digital zoom doesn't magnify the subject with glass, as an "optical (or lens-based) zoom" would. Instead, it merely crops in on the original image to enlarge it. Although it's convenient, it degrades image quality by giving you lower image resolution, or total number of pixels. It's better to just walk closer to your subject, if possible.

Kids at Carhenge near Alliance, Nebraska.

Next, a zoom lens can require more light to take a photograph than a fixed lens, and it increases the occurrence of camera shake that makes photographs blurry. Most professionals would always choose a single lens over a lesser-quality zoom lens if given the choice.

The plus side of a zoom lens is that it does give you more options for how you can take a photo. Using a longer lens helps to tighten in on the subject and reduce unwieldy backgrounds. And a shorter lens gives a wide-angle view that can make a small room seem big or show more of what's around a group of people. But if you have only a brief time to snap a photo, messing with the zoom might mean you miss the shot.

JPEG, RAW, or TIFF file capture

The JPEG format is the standard method for saving an image file for most cameras. Try to avoid a proprietary image format for a particular brand—meaning the camera doesn't automatically save images as a JPEG format—otherwise sharing your photos will be difficult (see chart on page 184). The JPEG format is universal. RAW file capture means the camera saves the data from your photograph without processing it. This is the digital equivalent of the venerable darkroom process of developing and printing your own photographs. It allows you total creative freedom, but it takes up much more space on your camera's memory card and on your computer's hard drive. It also requires Image-editing software capable of processing your camera's particular RAW file, as well as a computer that's fast enough to do so. The TIFF file format is a high-quality way to save an image but is much bigger than the JPEG and RAW file.

Memory cards

Digital cameras save their images to some sort of memory card. Some manufacturers use their own proprietary card (Sony, notably, uses its "Memory Stick"). The three most prevalent are compact flash (CF) cards, secure digital (SD) cards, and multimedia cards. There's no big advantage to any one, as they all do pretty much the same thing. It's a good idea to choose a camera that uses common cards, however, both because you can find them readily and because their prices are lower.

Automatic and/or manual focus

Auto focus is standard issue on most cameras. Some newer cameras have a "face detection" system that will attempt to focus on faces in the frame, as well as set the exposure so these come out correctly.

Manual focus is actually a great feature that a few point-and-shoots offer and all SLRs have. It's good to have because it allows you the creativity to focus on something that isn't in the middle and centered in the frame, as many auto-focus systems do by default.

Red-eye reduction

Red-eye happens when light is low and people's pupils are wide open. Your camera's flash fires so rapidly that pupils don't have time to close. The light from the flash literally bounces against the retina, causing a red reflection. Cameras attempt to avoid red-eye in two ways: They might use multiple pops of the flash that allow the subject's pupils to constrict; or software within the camera can sense the red-eye and reduce it. Image-editing software also commonly has a red-eye reduction method.

Using a flash this small inside the Lincoln Memorial in Washington, D.C., is a futile effort. The space is too vast. A better idea is to increase the ISO on your camera and use a slow shutter speed.

USB, FireWire, or wireless connection

Getting your photographs to your computer or to your lab can be done in several ways, but the easiest method is usually connecting your camera directly to your computer. Most cameras will have either a USB, FireWire, or wireless connection. Optionally, you can purchase a card reader, into which you plug the camera's memory card. This avoids having to use the camera's battery power to download images.

Pixel size

Generally, cameras begin at around 3 or 4 megapixels, plenty for most uses. More megapixels allows you more image resolution to crop a photograph, but it also means more space is needed to shoot and store the photographs.

Wide range of ISO speeds

The sensitivity of the camera's sensor to light is known as the ISO speed—it's the digital equivalent of film speed. The higher the ISO speed, the less light you need to take a photograph. Different cameras also have a different number of ISO speeds—higher speeds will allow you to shoot in dimmer lighting without a flash. This is a good feature to look for in a camera, no matter the price range. Look for ISO speeds from 100 up to at least 400 or higher.

Different auto-exposure modes

The different auto-exposure modes act as an easy, icon-guided exposure compensation. There are common settings synonymous with different types of photographs, and each of these expo-

Each camera manufacturer has its own file type for a raw image. Here's an overview.

Fuji: .raf

Canon: .crw; cr2

Kodak: .kdc; .dcr

Minolta: .mrw

Nikon: .nef

Olympus: .orf

Pentax: .ptx; .pef

Sony: .arw; .srf

Sigma: .x3f

sure modes has these pre-set. For example, if you're shooting a scenic image, you'd want to have a large enough depth of field—so on the "mountain" or "landscape" setting the camera will set a larger aperture number to ensure plenty of depth of field. Or for the snow setting, the camera will know to increase exposure (make the image brighter), because the snow is reflecting a lot of light. A portrait mode will reduce the depth of field by using a smaller aperture value to blur out the background and will also set the exposure settings for the center of the frame—where, most likely, the person's head will be.

More Advanced Features

These are the next step up. If you're serious about this hobby, keep an eye on these while camera shopping.

Aspect ratio

The traditional 35mm frame is a 3:2 ratio, meaning your image could be made into a print that would be three inches wide by two inches, or six inches wide by four inches. Many point-and-shoot cameras either give you the option or are preset with a 4:3 aspect ratio—the size a typical television or computer monitor displays. This makes for a more square photograph than the traditional 35mm frame.

Sensor size

As a general rule, the larger the sensor on your camera, the better quality your photograph will be. The advantage of an SLR camera is that it typically has a much larger sensor than a point-and-shoot does and, therefore, produces better image quality. But will you notice the difference in a print? If you're comparing a low-end point-and-shoot to an SLR, you probably will. But with a better-than-average point-and-shoot, the quality difference may be negligible. Remember, it's better to have a photograph with a less than perfect camera than to have no photograph at all because you didn't have a camera with you.

Tourists take pictures in the South Beach area of Miami Beach, Florida.

Direct-to-printer printing

Known by several different names, this technology allows the camera to link directly to the printer to print photos without a computer. If you think you'd want to print your photos at home with little editing, look for this feature.

Exposure compensation

When using an auto-exposure mode, the exposure compensation adjusts exposure when the camera would otherwise have a difficult time exposing correctly.

The auto-exposure function on cameras varies, but the underlying principle is the same: They all assume the subject is of average color and brightness—a color known as "middle gray." If you're photographing something darker than middle gray—maybe your black cat—you want to set the camera so it doesn't attempt to make the black cat gray through exposure changes. You would do this by decreasing the exposure compensation. On the other hand, if you're photographing friends on a bright, snow-covered mountain, you want to increase the exposure because the overall scene is brighter than middle gray.

Aperture and/or shutter-priority exposure modes

Despite the many auto settings on a camera, there are really only two settings to adjust: aperture and shutter speed.

A photograph requires light—and just the right amount of light at that. Some cameras use different methods for letting in light, but the basics are always the same. The first is shutter speed, or the length of time the shutter stays open. The next is aperture, or the diameter of the shutter opening. By adjusting these two settings, you affect what the photograph looks like.

Because both shutter speed and aperture determine how much light hits the sensor, both can affect the brightness of the image.

Aperture, however, also affects the depth of field. A very wide aperture (what pros would call "shooting wide open") limits the depth of field and blurs things that are either close to the camera or far away from it. A narrow aperture (or high aperture number) creates a long depth of field, meaning everything in the foreground and background is in focus.

By choosing shutter or aperture priority, the camera is letting you set the shutter speed or aperture, and it sets the other one. Why use this? Say you want to photograph your child's hands, and you don't want any focus on his striped sleeves. By setting a small aperture of maybe f/4, you will blur everything in the foreground and background—only his hands will be in focus. If you use a higher aperture, like f/16, a lot of his hands and his sleeves will be in focus, which might not make as good a picture. If you want to freeze action while your child plays in a sprinkler, use a high shutter speed of at least 1/500 of a second. Here, you put your camera on shutter-speed priority, and it will set the right aperture to take a correctly exposed photograph.

Manual-exposure mode

Selecting both the aperture and shutter speed is a more advanced way of shooting, and can be advantageous once you understand how the two relate to each other. On some cameras, however, changing these settings can be tedious and slow. If you think you want a camera

that has full manual-exposure mode, definitely try it out in the store before committing.

Selectable focus points

Most cameras assume you will be focusing in the center of the frame, because that's the most common place to put the subject. It's also not too creative. By having selectable focus points, you can choose to put the subject off center and have more possibilities for creative composition. Many cameras also have a "focus hold" setting, where you can hold down the shutter button halfway, and it will let you know it has focused on what's in the middle of the frame. You can then recompose the frame and press the shutter button all the way down to take the photo.

Different flash modes

The general idea of avoiding flash is probably one of the best for using point-and-shoot cameras. Flash is a very unnatural way of lighting a person or thing, and it often looks downright ugly. By using high ISO speeds you can avoid using flash. But if you have different flash settings, your camera will be able to intelligently mix its flash in with the right exposure setting—so you avoid the blast effect of direct flash.

Image stabilizer

If you aren't adept at setting the shutter speed and aperture on your camera, beware the thing that can mess up an otherwise good photograph: camera shake. On an automatic setting, many cameras may opt a shutter speed so slow that any movement of the camera will blur the image. Often the camera will warn you of this in various ways: blinking in the viewfinder or

A visitor to Denali National Park and Preserve in Alaska frames up the scene.

an audible alert. One way to reduce this problem: Stabilize the camera on a tripod or on any stable surface. Another way is to have the camera itself stabilize the image. This can minimize or even eliminate blur caused by the camera moving—but not by the subject moving. And therein lies the problem. Image stabilization is generally useful only if what you're photographing isn't moving as well. So while it can be helpful in some situations, it's not a perfect solution. On the other hand, it certainly won't hurt.

External flash connection

As already explained, your camera's flash isn't a good choice for natural-looking subjects. If your camera has other flash modes, they can greatly help the on-camera flash look better by balancing the available light with the flash. The alternative, if you must use a flash, is to use an accessory flash with an external connection. This allows you to move the flash away from the camera so it's no longer pointed directly in front of the subject. This alone can make the flash look much more attractive as compared to the camera's built-in flash.

INDEX

Boldface indicates illustrations.

ACKNOWLEDGEMENTS

My heartfelt thanks go out to everybody who has ever had to put up with me.

P.S. If you really must know who that is: It's John, Sharon, Faynell, Kathy, Cole, Ellen, Spencer, Katie and the studio crew, Mike Forsberg, Tom Swanson, the DeVries Family, and various pets including Sprinkles, Misty, Peanut, Buttons, Daisy, Brownie, Hamster-Veal, Bacon, Broiler, Snowflake, Prairie Dog, Joan van Bark, and especially, Muldoon.

—Joel Sartore

Many thanks go to Bronwen Latimer for the idea, the direction and the dedication required to make this book. To Fran Brennan, thank you for honing my work into error-free prose. To Joel Sartore, whose energy and drive has been a true pleasure to be around, thank you for sharing your admiration and knowledge of the natural world with me. The world is a much better place with the significant photography you have created.

Thanks Momma and Pappa. A lot.
Thanks to all the bohemian English teachers I had.
Thanks to Abigail T. for the mind-clearing frisbee respites and your verve. It's a real shame you can't speak English.

And: Mojo's in Austin, Simon, TRA, Chez Tunlaw, Salif Keita, Tosca, Sie and my front porch.

—John Healey

PHOTO CREDITS

All photographs are by Joel Sartore except for the following: p. 16, Courtesy of Nikon, Inc.; p. 17, Mark Thiessen/NGS; p. 50, diagram by Slim Films; p. 54-55, Mark Thiessen/NGS, p. 57 border, Mark Ballantyne/iStockphoto.com; p. 130, Library of Congress, LC-U3Z62-74309; p. 159, Richard Olsenius; p. 160, Mark Thiessen/NGS, p. 167 border, C Squared Studios/Getty Images, p. 170, Mark Thiessen/NGS.

PHOTOGRAPHING YOUR FAMILY

BY JOEL SARTORE
WITH JOHN HEALEY

Published by the National Geographic Society

John M. Fahey, Jr., President and
　　　Chief Executive Officer
Gilbert M. Grosvenor, Chairman of the Board
Nina D. Hoffman, Executive Vice President;
　　　President, Book Publishing Group

Prepared by the Book Division

Kevin Mulroy, Senior Vice President and Publisher
Leah Bendavid-Val, Director of Photography
　　　Publishing and Illustrations
Marianne R. Koszorus, Director of Design
Barbara Brownell Grogan, Executive Editor
Elizabeth Newhouse, Director of Travel Publishing
Carl Mehler, Director of Maps

Staff for This Book

Bronwen Latimer, Editor and Illustrations Editor
Peggy Archambault, Art Director
Fran Brennan, Text Editor
Katie Joseph, Editorial Consultant
Frances Schoonveld, Editorial Consultant
Grace Young, Editorial Consultant
Dave Young, Editorial Consultant
Marshall Kiker, Illustrations Specialist
Mike Horenstein, Production Project Manager
Jennifer A. Thornton, Managing Editor
Gary Colbert, Production Director

Manufacturing and Quality Management

Christopher A. Liedel, Chief Financial Officer
Phillip L. Schlosser, Vice President
John T. Dunn, Technical Director
Chris Brown, Director
Maryclare Tracy, Manager
Nicole Elliott, Manager

Founded in 1888, the National Geographic Society is one of the largest nonprofit scientific and educational organizations in the world. It reaches more than 285 million people worldwide each month through its official journal, NATIONAL GEOGRAPHIC, and its four other magazines; the National Geographic Channel; television documentaries; radio programs; films; books; videos and DVDs; maps; and interactive media. National Geographic has funded more than 8,000 scientific research projects and supports an education program combating geographic illiteracy.

For more information, please call
1-800-NGS LINE (647-5463)
or write to the following address:

National Geographic Society
1145 17th Street N.W.
Washington, D.C. 20036-4688 U.S.A.

Visit us online at www.nationalgeographic.com/books

For information about special discounts
for bulk purchases, please contact
National Geographic Books Special Sales:
ngspecsales@ngs.org

For rights or permissions inquiries, please contact
National Geographic Books Subsidiary Rights: ng-bookrights@ngs.org

CIP Data available upon request

ISBN 978-1-4262-0218-6

Printed in China